Basic Flower Painting

TECHNIQUES IN
WATERCOLOR

Basic Flower Painting

TECHNIQUES IN
WATERCOLOR

Edited by

RACHEL RUBIN WOLF

NORTH LIGHT BOOKS
CINCINNATI, OHIO

Basic Flower Painting Techniques in Watercolor. Copyright © 1996 by North Light Books. Manufactured in China. All rights reserved. No part of this book may be reproduced in any form or by any electronic or mechanical means including information storage and retrieval systems without permission in writing from the publisher, except by a reviewer, who may quote brief passages in a review. Published by North Light Books, an imprint of F&W Publications, Inc., 1507 Dana Avenue, Cincinnati, Ohio 45207. (800) 289-0963. First edition.

Other fine North Light Books are available from your local bookstore, art supply store or direct from the publisher.

02 01 8

Library of Congress Cataloging-in-Publication Data
Basic flower painting techniques in watercolor / edited by Rachel Rubin Wolf.
 p. cm.
Includes index.
ISBN 0-89134-730-5 (pbk. : alk. paper)
 1. Flowers in art. 2. Watercolor painting—Technique. I. Wolf, Rachel Rubin.
ND2300.B37 1996
751.42′2434—dc20

95-48000
CIP

Art on page 2: Windsor Red, Frank Nofer, 21½″ × 16½″, private collection; page 6: The Sunseekers, Frank Nofer, 17″ × 13⅜″, collection of Dr. Alfred Beattie.

The following artwork originally appeared in previously published North Light Books or *The Artist's Magazine*. The initial page numbers refer to pages in the original work; page numbers in parentheses refer to pages in this book.

Freeman, Kass Morin. *Splash 3 Ideas and Inspirations* ii (21)
Kunz, Jan. *Painting Watercolor Florals That Glow* Pages 4-9 (10-15), 12-13 (16-17), 20 (20), 24-33 (22-31), 94-95 (36-37), 50-53 (106-109), 74-75 (18-19), 98-101 (110-113), 86-91 (114-119); *Splash 1* Page 48 (123)
Johnson, Cathy. *Creating Textures in Watercolor* Pages 80-83 (32-35)
Nofer, Frank. *How to Make Watercolor Work for You* Pages 45 (6), 76 (8), 123 (2), 128-129 (38-39), 130 (5)
Treman, Judy. *The Artist's Magazine*, March 1994, Building Brilliant Watercolors Pages 74-79 (40-45)
Cole, Jean. *The Artist's Magazine*, November 1992, Flowers That Glow on Your Pages 64-69 (46-51)
Krell, Mary Kay. *The Artist's Magazine*, October 1991, Soften the Blow of Reality Pages 48-53 (52-57)
Francis, Anna. *The Artist's Magazine*, May 1991, Amaryllis in Action Pages 62-67 (58-63)
Schutzky, Marilyn. *The Artist's Magazine*, November 1990, Dramatize a Close-Focus Floral Pages 64-69 (64-69)
Clarke, Mary Ann. *The Artist's Magazine*, August 1990, Create Glowing Florals with Crumpled Paper Pages 44-49 (70-75)
Buer, Barbara. *New Spirit of Water Color* Pages 11-13 (76-79); *Splash 1* Pages 56 (87), 57 (86)
Adams, Norma Auer. *Painting With Passion* Pages 130-131 (80-81)
Lawrence, Skip. *Painting Light and Shadow in Watercolor* Pages 128-129 (82-83)
Kaplan, Sandra. *Dramatize Your Paintings with Tonal Value* Pages 28-29 (84-85)
Jubb, Kendahl Jan. *Dramatize Your Paintings with Tonal Value* Pages 110-111 (88-89)
Nyback, Arne. *The New Spirit of Watercolor* Pages 114-117 (90-93)
McKasson, Joan. *The New Spirit of Watercolor* Pages 100-101 (96-97)
Bergstrom, Edith. *The New Spirit of Watercolor* Pages 98-99 (94-95)
Nice, Claudia. *Creating Textures in Pen & Ink with Watercolor* Pages 104-111 (98-105)
Belanger, Richard. *plash 3 Ideas & Inspirations* Page 14 (120)
Atwater, John. *Splash 1* Page 111 (121)
Stephenson, Larry. *Splash 3 Ideas & Inspirations* Page 118 (122)
Rasmussen, Susan McKinnon. *Splash 1* Page 76 (124)
Pember, Ann. *Splash 3 Ideas & Inspirations* Page 117 (125)

Edited by Rachel Rubin Wolf
Content Edited by Joyce Dolan
Cover designed by Angela Lennert Wilcox
Cover illustration by Cathy Johnson

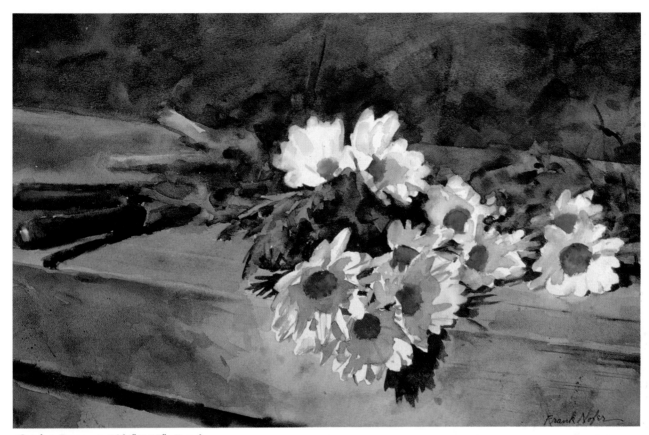

*Garden Bouquet, 10¾" × 17", Frank
Nofer, collection of Mrs. George Lemmon*

ACKNOWLEDGMENTS

The people who deserve special thanks, and without whom
this book would not have been possible, are the artists whose
work appears in this book. They are:

Norma Auer Adams	Mary Kay Krell
John Atwater	Jan Kunz
Richard Berlanger	Skip Lawrence
Edith Bergstrom	Joan McKasson
Barbara Buer	Claudia Nice
Mary Ann Clarke	Frank Nofer
Jean Cole	Arne Nyback
Anna Francis	Ann Pember
Kass Morin Freeman	Susan McKinnon Rasmussen
Cathy Johnson	Marilyn Schutzky
Kendahl Jan Jubb	Larry Stephenson
Sandra Kaplan	Judy Treman

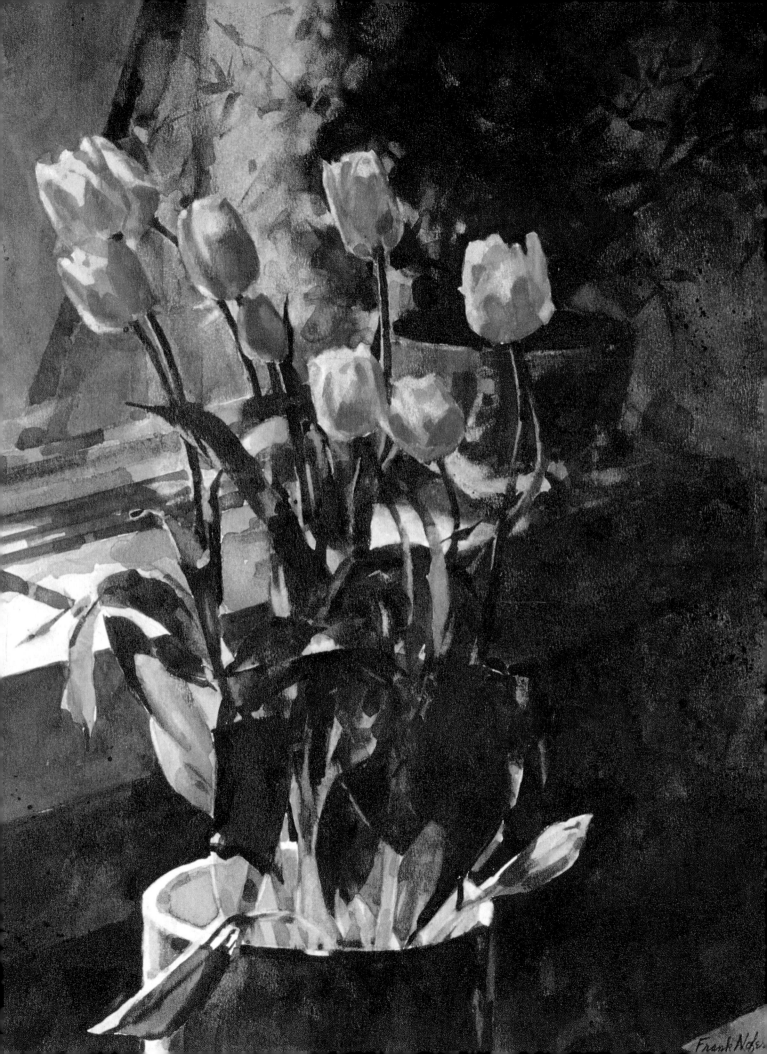

TABLE
of
CONTENTS

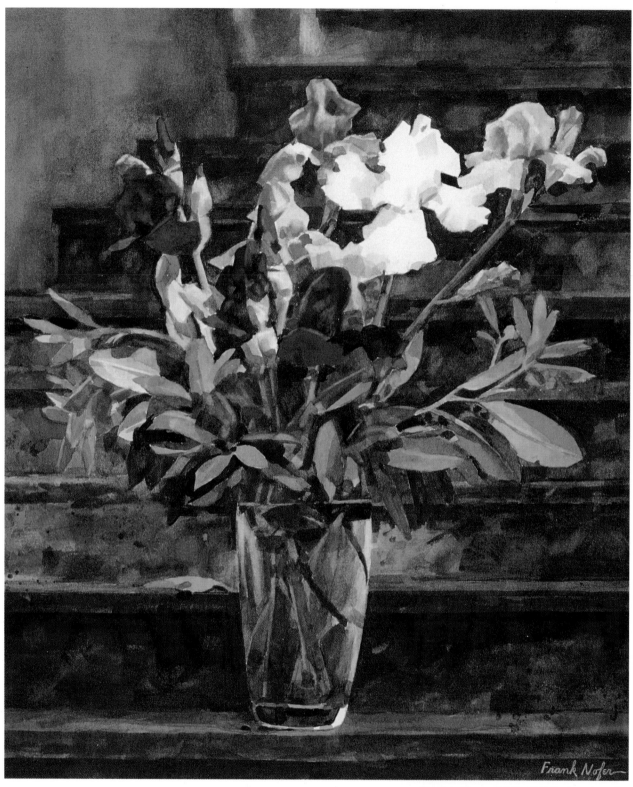

Terrie's Flags, 15¼" × 13½", Frank Nofer,
private corporate collection

INTRODUCTION

Flowers, teeming with brilliant colors, subtle shadings and an inexhaustible variety of shapes and textures have traditionally been a favorite subject for artists. Watercolor is the perfect medium to capture their radiance and purity of color.

We have assembled this book from some of the best teaching available on painting flowers with watercolor. We've started at the very beginning with the basic supplies you'll need and information on color. There's a large section of twenty-five step-by-step demonstrations and a section of invaluable information about flower shapes and textures. We've also included tips on painting interesting elements such as dewdrops.

The next time a field of wildflowers takes your breath away or the elegance of a single rosebud leaves you speechless, grab this book, along with your palette and brushes. It will take practice and effort, but the process will be fun and rewarding and you can watch your watercolor garden grow along with your talent.

Basic Supplies

This section is aimed at the painter who is new to watercolor and needs to get outfitted. For those of you who have been painting for a while, you may not need new supplies, but look at your palette and check to see that all the pigments and mixing areas are clean.

Brushes

At one time the only good brushes were made of sable hair and were very expensive! Happily, times have changed, and there are many good synthetic brands on the market.

Select a brush that holds water well and that springs back into shape after each stroke. Most good art supply dealers will supply a cup of water to test brushes before purchase.

Choose the size brush that fits the job it is intended for. Just as you wouldn't paint a house with a trim brush, you shouldn't try to run a wash with a tiny brush or paint petals with a mop!

You don't need to have all of the brushes pictured. If you have no. 14, 8 and 4 rounds and a 1-inch flat brush, you'll get along very well. The more you paint, the more brushes you'll collect. Remember that old saying about a craftsman being only as good as his tools? They were talking about watercolor brushes!

Modified Oil Brushes

There will be times when you will want to scrub out an offensive spot, lift a highlight or soften an edge. This is where modified oil brushes come in handy. Perhaps you can persuade an oil-painter friend to donate a couple of old bristle brushes to the cause.

Oil brushes can be modified for special use (page 11). The first is a flat no. 6 bristle brush used to lift highlights and make corrections; the tip of this brush is cut shorter to enhance its stiffness. The second brush is a round no. 2 bristle brush. The tip of this brush is cut at an angle to form a point, creating a great tool to lift small highlights with.

Brushes can be modified by wedging the bristles between heavy paper and cutting the tips with a utility knife. However, wrapping the bristles tightly with masking tape and cutting them right through the masking tape with scissors or a craft knife works just as well and is easier. The tape will come off easily after the surgery. Sharpening the handle of one of these brushes in a pencil sharpener creates a useful tool for drawing on damp paper.

Another useful oil brush (not pictured here) is a flat no. 2 Grumbacher Erminette. It is small (only about ⅛-inch wide), not too stiff and very maneuverable. Use it to soften edges.

Palette

The selection of a palette is largely a matter of personal choice, but it should have deep wells to hold the paint and large areas for mixing. There are many white plastic palettes on the market that are easy and convenient to use. Some artists prefer baked-enamel palettes because they don't stain readily and fit eas-

A selection of brushes in frequently used sizes. These examples have a few years on them, but a good brush can be a good friend for a long time.

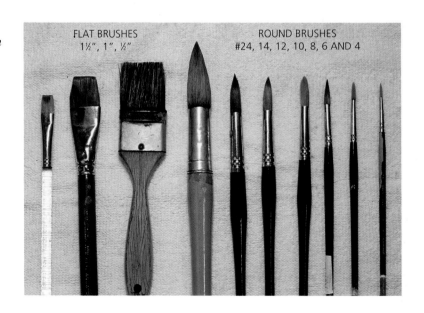

FLAT BRUSHES
1½", 1", ½"

ROUND BRUSHES
#24, 14, 12, 10, 8, 6 AND 4

ily under the faucet for cleaning. Try a large (16″ × 11¼″) butcher tray for mixing big washes.

Pencils

To make graphite transfer paper (see pages 12 and 13) you will need a 4B or 6B graphite stick or a pencil that is entirely graphite, such as a Pentalic Woodless Pencil. For sketching in the field, you can usually use an HB or a 4B. For preparing the drawing in the studio, you might prefer an ordinary no. 2. A pencil that is too hard scars the paper; a soft pencil makes a thick line and dirties both the paper and your hand.

Everyday Tools

You'll find a variety of everyday things that can contribute to your paintings. An old towel or rag will be useful for spills. Sponges and facial tissue are necessary to dry brushes and blot areas of paintings. Artificial sponges are available at hardware stores, but be sure you get one made of *cellulose*; other artificial sponges are not absorbent enough. A small, elephant-ear-shaped natural sponge is useful for lifting out light areas in a wet painting.

Some artists prefer terry cloth bar towels. They are about 14″ to 16″ square; you can buy them from a restaurant supply house or by the pound from a laundry after they are too old for commercial use. These towels are rugged and easily cleaned in the washing machine.

Facial Tissues

It is difficult to paint without facial tissues. You need them to wipe out the palette, pick up a spill or remove a misplaced color.

Knife

A craft knife or razor blade can be used to make an acetate frisket or pick out a highlight.

Liquid Frisket

Liquid frisket is used to mask areas you want to protect when applying washes of color. Use it sparingly, because the edges appear hard after it is removed. However, there are times when painting around objects is simply impractical, and nothing else works as well.

Liquid frisket is sold at most art stores; Winsor & Newton calls their product Art Masking Fluid, and Grumbacher's brand is Misket. Liquid frisket can ruin your brush if you don't follow the directions on the bottle carefully.

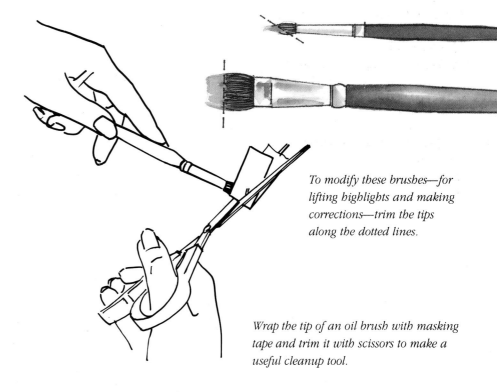

To modify these brushes—for lifting highlights and making corrections—trim the tips along the dotted lines.

Wrap the tip of an oil brush with masking tape and trim it with scissors to make a useful cleanup tool.

Watercolor Paper

Have your paper, drawing board and staple gun ready before you begin.

M any watercolor instructors urge beginning painters to work on good-quality watercolor paper. But if all you want to do is practice brushstrokes, why not use old newspaper want ads? Even experienced watercolorists have real problems with poor, unwieldy paper.

What is good watercolor paper? If you don't know how to judge good paper, start with a brand name that is recognized by artists as being top quality. The best is 100 percent rag, hand- or mold-made; the top brands include Arches, Holbein, Fabriano, Winsor & Newton and Strathmore watercolor board.

Most papers come in three surfaces: hot press (smooth), cold press (medium) and rough. In addition, watercolor paper comes in various weights; the most popular are 140 lb. and 300 lb. (the weight refers to the weight of 500 sheets). A standard sheet is 22″ × 30″. You can also purchase larger (elephant-size) sheets or buy paper by the roll.

Stretching Paper

Stretching paper prevents it from buckling once water is applied. If 140-lb. paper is used, most artists recommend stretching it. There's enough to think about while painting without worrying about wrinkled paper. Stretching isn't required for 300-lb. paper.

Stretching paper is easy. Have everything ready beforehand—you don't want the paper to begin to dry while you are working with it. You will need a drawing board slightly larger than the paper. Basswood, foamcore or "gator" board all work well. You will also need a staple gun. You can use a regular desk stapler, but if your board is extremely hard you

may need the heavier industrial type.

Fill a large container (you can use a sink or bathtub) with cool water. Place the paper into the water. If it doesn't fit, make it into a soft roll. After two to five minutes (when you are sure the entire paper is thoroughly wet), remove the paper and place it down flat on your drawing board. Immediately staple all around the edge, placing staples every two to four inches. Paper exerts a great deal of pull as it dries, so be sure the staples are well in place. Roll a clean terry cloth towel over the surface of the paper to pick up excess water and speed drying. Lay the drawing board on a horizontal surface to dry; you don't want the water to run to one side and cause a buckle.

Transfer Paper

Flowers have many complicated shapes, so it helps to plan on tracing paper, as you will soon see. Once you are satisfied with the drawing, transfer it onto the watercolor paper. Some artists prefer to use graphite transfer paper they've made rather than transfer paper. Using the paper you make yourself is almost like drawing directly onto the watercolor paper; commercial papers sometimes leave a line you cannot erase, as well as a white margin on either side that repels the paint.

To make graphite transfer paper, you need a piece of good quality tracing paper. Cut it large enough to use again and again with drawings of various sizes.

Rub one side of the paper with a soft graphite stick or woodless pencil until it is pretty well covered. A crisscross motion works very well. Once this is accomplished, dampen a piece of facial tissue with lighter fluid or rubber cement

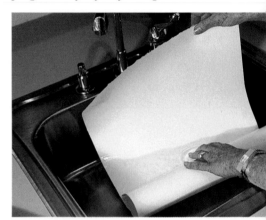

If your paper is too large to fit into the sink, make it into a soft roll and gently submerge it. Be careful not to fold or scar the paper. Hold it under water until every part is thoroughly wet.

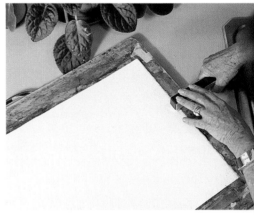

Remove the paper and lay it on your drawing board. Immediately staple opposite sides of the paper. Continue around the entire board, placing staples two to four inches apart.

Place frosted acetate over the painting and outline the area you wish to lift.

Move the acetate to a piece of cardboard or thick paper and cut out the shape you have outlined.

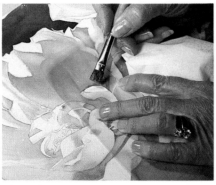

Place the acetate into position over the painting and remove the offending area with a damp, stiff brush.

FROSTED ACETATE

You will find many uses for frosted, or matte (depending on the brand name), acetate; the sheets are translucent and the surface readily accepts pen or pencil. The acetate chosen should be thick enough to withstand handling (0.005 or 0.007 is best). If you have difficulty in obtaining frosted acetate, ask an art supply dealer to get it for you. Grafix Acetate and Pro/Art are two of the brands available; they come in tablets of 9″ × 12″ sheets. Don't buy clear acetate—it's too smooth to accept the pencil.

The transparent quality of frosted acetate makes it possible to draw on several pieces and then superimpose them on one another to create a composition.

You can make an acetate frisket for use in lifting color from small areas. Just place the acetate over the painting and use a pencil to outline the area to be lifted. Remove the acetate and carefully cut out the outlined shape with an craft knife. Next, place the acetate frisket over the painting and remove the offending area with a moistened stiff brush (like the modified oil brush). Corrections of this kind defy detection, but they should be used only when the painting is near completion. Stiff brushing can distress the paper to the point that it will not accept more pigment well.

thinner and, using a circular motion, rub over the blackened surface. The graphite will smear at first, but keep rubbing until the surface takes on a more or less uniform value. When the transfer paper is finished, you can bind the edges with transparent tape to keep the paper from tearing after repeated use.

Before you use your new transfer paper, be sure you have shaken or dusted all the excess graphite from the surface to prevent it from soiling your watercolor paper. Use it just as you would any other transfer paper. Put it beneath your drawing graphite side down and trace your drawing onto the watercolor paper.

Paint

In this book you will be working mainly with transparent watercolors. The pigments that come in tubes are easiest to work with. You can squeeze out a fresh amount when you begin a painting, and the soft consistency makes it easy to use.

Many people consider all water-based paint to be watercolor, including acrylics, tempera or gouache. Be careful to get transparent *watercolor*. The label will read something like "water colors, artists' quality," "artists' water colour" or "professional artists' watercolor," depending on the brand.

There are many good brands of watercolor pigments. The well-known names include Winsor & Newton, Grumbacher, Holbein and Liquitex. The color may vary slightly between different brands, but the quality is consistently high.

How the pigments are arranged on your palette will vary. For example, some rectangular palettes have warm colors on one side and cool colors on the other. If you are happy with the way your palette is arranged, stay with it. The arrangement isn't nearly as important as knowing where a pigment is located. You don't want to stop and look around the palette for a special color while the wash is drying!

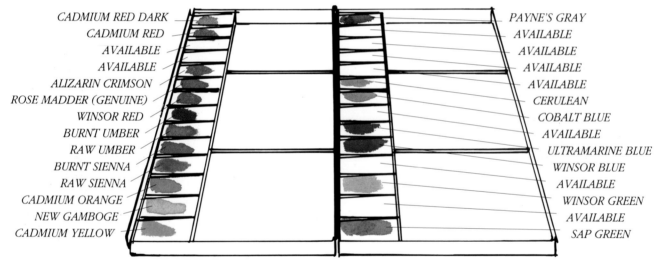

CADMIUM RED DARK
CADMIUM RED
AVAILABLE
AVAILABLE
ALIZARIN CRIMSON
ROSE MADDER (GENUINE)
WINSOR RED
BURNT UMBER
RAW UMBER
BURNT SIENNA
RAW SIENNA
CADMIUM ORANGE
NEW GAMBOGE
CADMIUM YELLOW

PAYNE'S GRAY
AVAILABLE
AVAILABLE
AVAILABLE
AVAILABLE
CERULEAN
COBALT BLUE
AVAILABLE
ULTRAMARINE BLUE
WINSOR BLUE
AVAILABLE
WINSOR GREEN
AVAILABLE
SAP GREEN

This is an example of how you can lay out colors on a palette. The available spaces can be used when you want to add a special color, such as Rose Dore, Phthalo Red, Winsor Violet, Cobalt Violet, Hooker's Green Dark, Prussian Blue, Antwerp Blue or Manganese Blue, for a particular painting.

Painting Tips

It may seem like a trivial thing, but a well-organized space can help you work more efficiently. When painting, your entire concentration should be on the painting itself. By the time you put the brush to paper, everything else should be in order. A clean paint rag should be positioned next to your palette for immediate use. The water bucket should be large and full of clean water. All the brushes you might need should be placed for easy access (you can use a jar or carousel), and facial tissue should be within reach.

Clean Your Palette and Paint

Palettes get dirty, so most artists wipe them out frequently. When cleaning your palette, don't overlook the pigment. Color is transferred from pigment to pigment during the painting process, and colors can lose their brilliance. Take your palette to the sink and run a gentle stream of cool water directly onto the pigments. Using a small brush, gently re-move any color that doesn't belong. Give the palette a quick shake to remove excess water, and wipe it dry. Be very careful, especially if the pigment is fresh, and very little pigment will be lost. The pigment that remains will be fresh and brilliant.

Small Cautions That Can Help

Keeping the water container filled to the top will prevent missing the water alto-gether. It's easier than you think to bring a dry or dirty brush to the paper! Use a clean paint rag and replace it as neces-sary.

The Most Important Tip

Don't listen to any of this advice if it doesn't sound right for you. That goes for any other advice you may have heard. Watercolor painting is a very per-sonal experience. You are in charge. Have faith in your own ability to know what works for you.

Use a gentle stream of water to clean your palette and the pigments when necessary during the painting process.

A well-organized work space can make painting easier. Your paint rag, water and facial tissue should always be within easy reach.

Color and Watercolor

Color is a highly personal element, and learning to use it effectively is a hands-on process. It would be worth your while to learn all you can about color; there are many fine books available on color and color theory.

Although some of this material may seem rather basic, perhaps this quick review will remind you of some things long forgotten. Like chicken soup, "it can't hurt!" If you are new to painting or are unsure about color, this is information you need.

What Is Color?

We sense color when our eyes are struck by light waves of varying lengths. Our eyes pick up these waves and translate them as degrees of light. If there is no light there is no sight—as you know if you have ever experienced total darkness.

Even though we call it "white light," the light that comes from the sun contains all the colors we see around us. Every colored object contains *pigments* that absorb certain rays of color and reflect others. For example, a banana is yellow because the pigment in its skin reflects only the yellow light we see and absorbs all the other colors.

Through the years, some materials have been found to be especially rich in pigment. These are the materials that are purified and made into the paints we use.

Hue

Hue is the term used to name a color: It has nothing to do with whether a color is intense or pale, dark or light. Red, green, yellow and blue are hues.

Primary Colors

The *primary colors* are red, yellow and blue. These colors cannot be made with a combination of any other pigments.

Secondary Colors

Secondary colors are those colors we can make by mixing the primary hues. Each secondary is a combination of the primaries on both sides of it: Red and blue make purple, red and yellow make orange, and blue and yellow make green. All the other colors are some mixture of the three primaries and three secondary colors.

Complementary Colors

Placing the primary and secondary colors equidistant from one another and filling in the spaces by mixing adjacent colors creates a color wheel. The colors located opposite one another are called *complementary colors.* Red and green, yellow and purple are examples of complementary colors. When complementary colors are mixed, the result is a neutral gray. Complementary colors in dark values are almost always muddy.

Warm and Cool Colors

When we speak of *warm* and *cool* colors, we are talking about color *temperature,* not about value or color intensity.

Many of the pigments used in watercolor have warm and cool versions of the same color. Alizarin Crimson is a cooler red than Cadmium Red, for example. The colors on the left of the chart (page 14) are somewhat warmer than those on the right.

Value

Value refers to the lightness or darkness of a color. Different pigments have different *value ranges*—the number of intermediate values you can get between a color used directly from the tube (darkest value) and the faint tint obtained by gradually adding water. In the examples

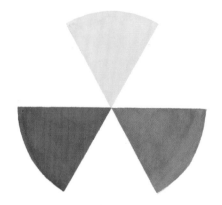

Primary colors

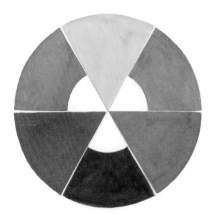

Primary and secondary colors

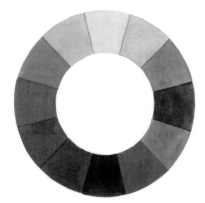

Color wheel

Basic Flower Painting Techniques in Watercolor

at right, yellow at its darkest·has only a short value range; Alizarin Crimson, on the other hand, has a very long value range. Cobalt Blue's range is somewhere between the two.

Watercolor Pigments

Most professional watercolor pigments are permanent and chemically stable; they are as enduring as oil pigments. Watercolors do have unique qualities, however, that need to be understood.

Opaque and Transparent Pigments

You don't have to work with watercolor very long before you realize that there are two kinds of watercolor pigments. Some pigments display a fair degree of opacity; others are transparent.

Think of *opaque* (or *precipitating*) colors as being made up of microscopic granules of pigment. When we paint with opaque colors, little chunks of pigment are deposited on the surface of the watercolor paper. When light is returned from an opaque color, it reflects only from the pigment granules. *Transparent* (or *staining*) colors are more luminous than opaque ones, because light rays penetrate the thin film of transparent pigment and reflect the white paper beneath.

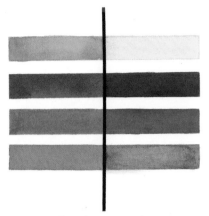

Warm and cool versions of the same hue

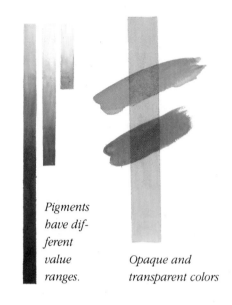

Pigments have different value ranges.

Opaque and transparent colors

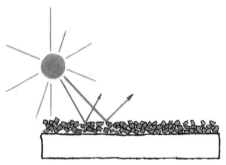

Light bounces off color granules of opaque pigments, but reflects the white paper beneath transparent pigments.

Using Color Temperature to Enhance Flower Colors

L et's paint a poppy using what we
have learned about how the color of
objects is affected by sunlight.

Step One

Sketch the poppy onto your watercolor
paper.

Step Two

Study the drawing; paint a very pale
wash of new gamboge on the vertical
surfaces that receive direct light. Do not
paint a solid yellow across these pet-
als—the edges are a slightly deeper hue
that quickly washes out to paper color.

Step Three

Paint horizontal areas that reflect the
sky, as well as petals that turn from the
light, with a pale wash of Cobalt Blue.

Notice how at first petal A faces the light,
then it turns and the color temperature
becomes cooler. The yellow center is
painted last.

Step One

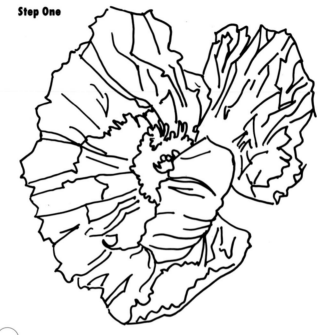

Areas Facing the Sun

Areas Reflecting the Sky

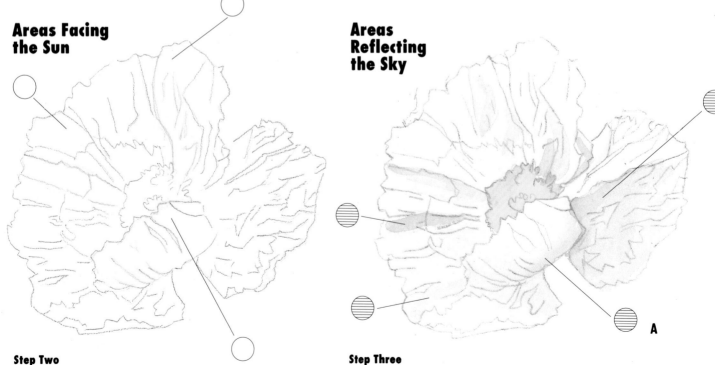

Step Two

Step Three

A

Step Four

Mix a puddle of Cobalt Blue with a touch of Winsor Blue and test it to be sure it is value 4 or 5 when dry. Once you are satisfied, paint the shadow shapes. Your brush should hold enough pigment to paint the entire shadow area. While the paint is still wet, charge in New Gamboge and Rose Madder where you want to suggest reflected light. The color won't go exactly where you planned, but resist the temptation to make corrections. Everything will take its place in the next step. To go back is to invite trouble.

Decide on the value of the yellow center; paint the shadow four values darker.

Step Five

Use a middle-value Cobalt Blue to model the shapes that give the wrinkled appearance to the poppy. You can use the same blue to model shapes within the shadow areas. Next, darken the cast shadows where required (areas *A* and *B*).

The final step is to suggest the stigma by adding crevice darks in the center of the flower.

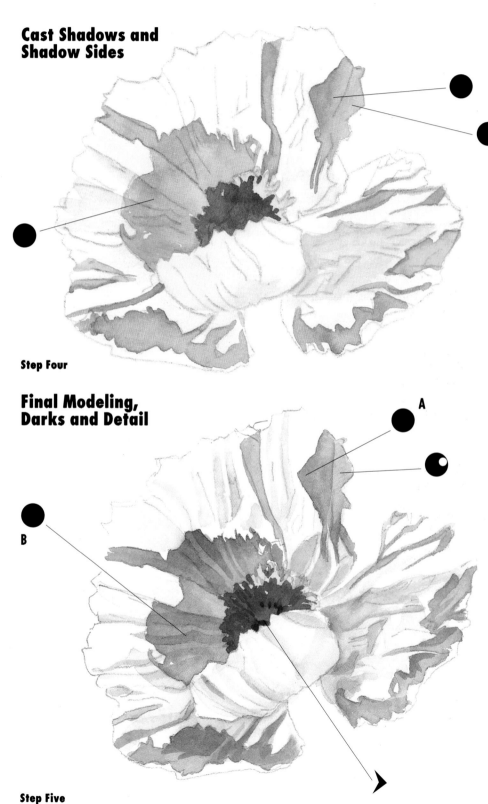

Cast Shadows and Shadow Sides

Step Four

Final Modeling, Darks and Detail

A

B

Step Five

Flower Forms and Textures

Anatomy may sound like a strange word to show up in a book on floral painting. Flowers are a natural watercolor subject due to their splash and color, but to paint them convincingly we need to know not only how flowers are put together, but a great deal more.

The purpose of this chapter is to heighten your awareness of the forms, colors, textures and growth patterns of the flowers you paint. Whether your goal is a detailed portrait of flowers or a loose interpretation of their form and brilliance, the better you know your subject, the better your chances for a successful painting.

Anatomy of a Flower

From an artist's point of view, a flower is made up of basic forms. *Form*, or *shape*, is important because humans see only shapes, values, edges and color; shape identifies the object. Awareness of subtle differences among shapes, and the ability to transfer them to the paper, is an important part of your development as an artist. Flowers possess many shapes, and we must train ourselves to see them. Value and edges further identify objects and add detail and interest.

Before we get to the nitty-gritty of drawing flowers, there are a few terms you should know. As you may remember from high school biology class, flower parts have names, so rather than direct you to "that little thing sticking up in the middle," a diagram of flower parts is provided. This is as technical as we will get!

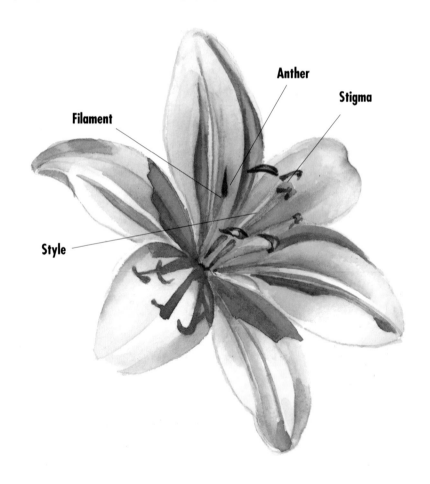

Filament

Anther

Stigma

Style

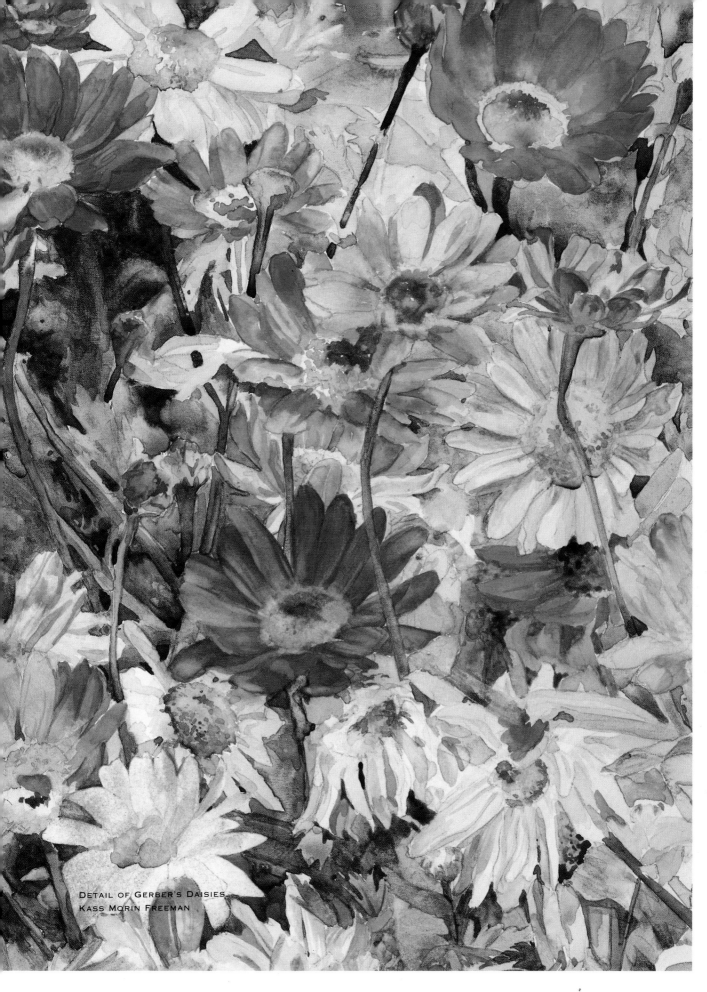

DETAIL OF GERBER'S DAISIES
KASS MORIN FREEMAN

Disk-Shaped Flowers

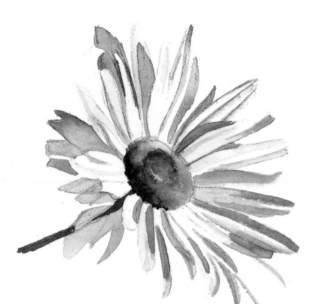

D aisies and similar flowers are shaped like a disk or a thin slice of a cylinder. Viewed straight on, these flowers are circular, with petals that radiate from the center. Color, shape and size of the petals vary depending on the specimen.

Viewed from an angle, the shape is elliptical. The disk-shaped flowers in this illustration are modified to represent daisies.

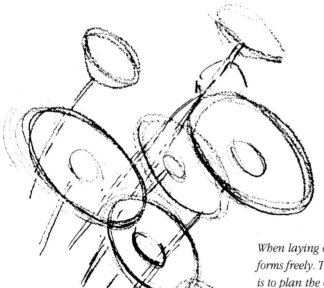

When laying out these sketches, draw the forms freely. The purpose of these drawings is to plan the overall shapes, locate the stems, and determine the placement of each blossom.

A daisy is formed like a disk or a thin slice of a cylinder. Use cylindrical shapes to help determine the placement of the daisies. The stems are long, slender cylinders and appear to emanate from the center of each disk shape. Notice that the partly opened blossoms are sketched as modified cones. Seeing objects as basic forms makes them easier to draw.

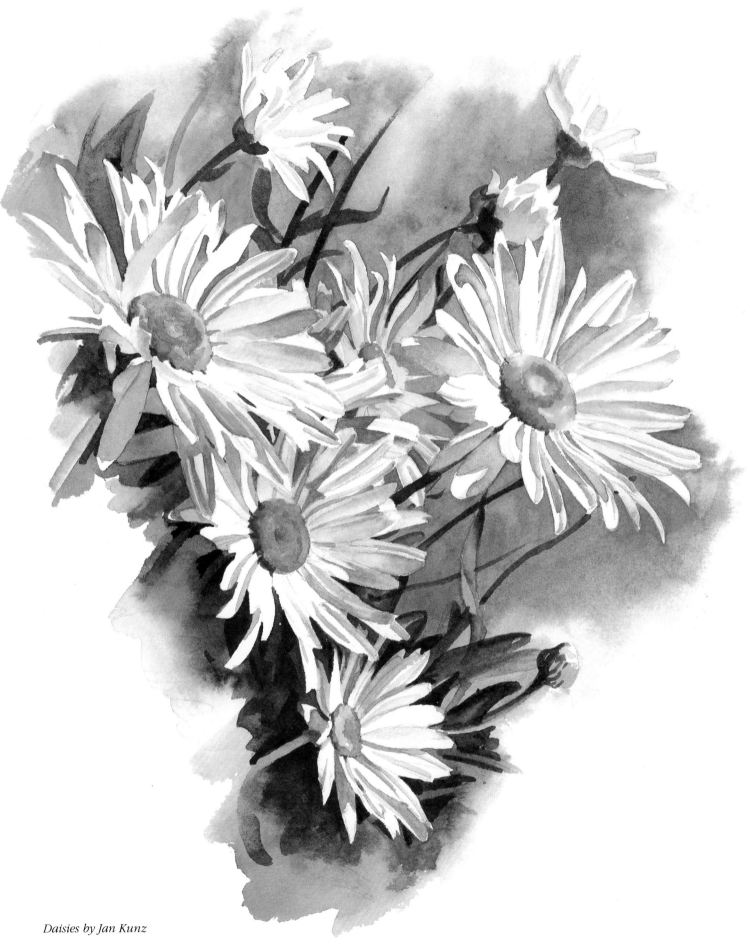

Daisies by Jan Kunz

Flower Forms and Textures

Sphere-Shaped Flowers

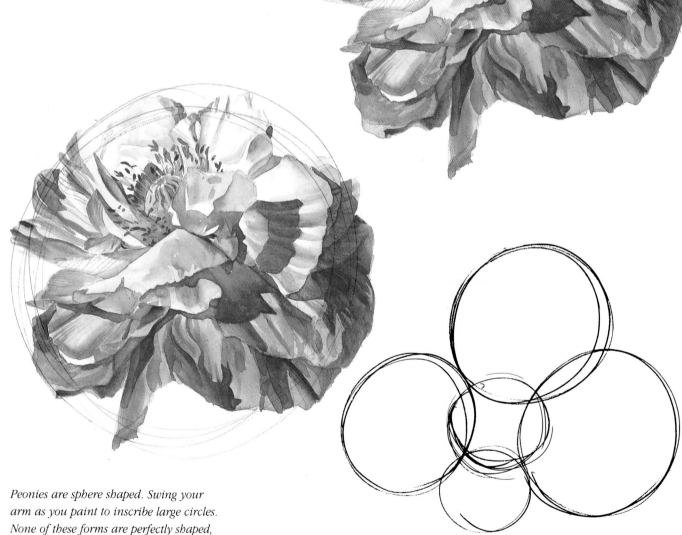

Many flowers are spherical; thistles, roses and peonies are three. To paint these flowers, begin with a sphere. The particular variety of flower is of secondary importance.

In this illustration, notice that the emphasis is on the sphere shape. Sure, you can have fun painting all the petals to make it look complicated. Every brushstroke here, however, was intended to enhance the feeling of roundness.

Peonies are sphere shaped. Swing your arm as you paint to inscribe large circles. None of these forms are perfectly shaped, but few shapes in nature are geometrically perfect. Nonetheless, there is a feeling of roundness.

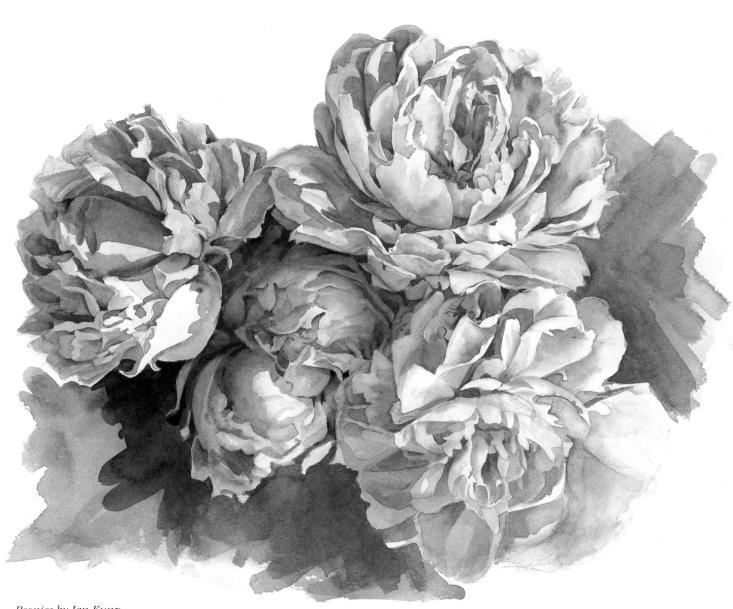

Peonies by Jan Kunz

Cone-Shaped Flowers

The cone shape is very common among flowers; lilies, foxgloves, lilacs, larkspurs and many others are basically shaped like a cone. Some flowers, such as rhododendrons and hyacinths, have individual cone-shaped flowers, but their blooms are composed of several individual flowers. The collection of individual blooms forms a sphere or a cylinder.

The foxglove bloom is a collection of bell- or cone-shaped blossoms growing on a single cylindrical stem. Once the basic form is established, it is easy to suggest a field of these beautiful wildflowers using simple cone shapes.

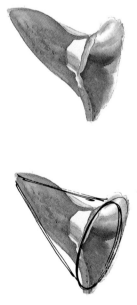

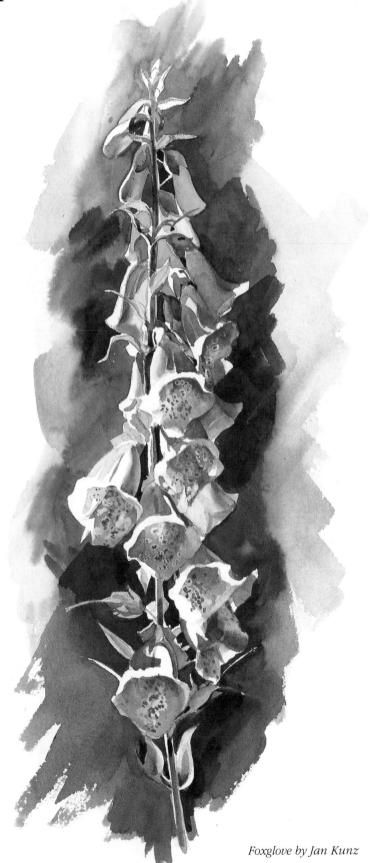

Foxglove by Jan Kunz

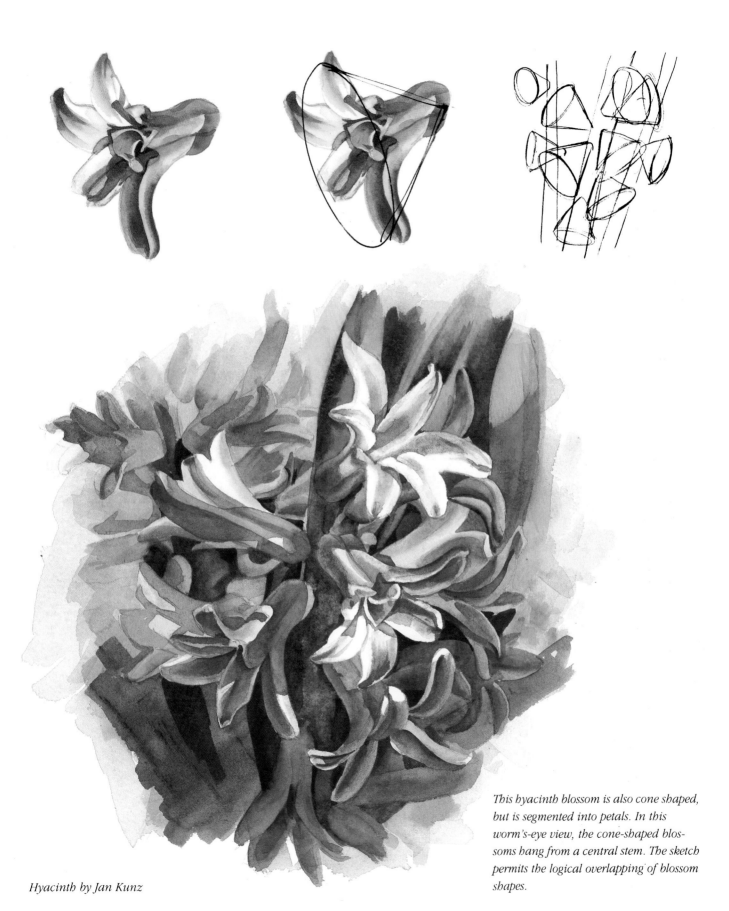

This hyacinth blossom is also cone shaped, but is segmented into petals. In this worm's-eye view, the cone-shaped blossoms hang from a central stem. The sketch permits the logical overlapping of blossom shapes.

Hyacinth by Jan Kunz

Multi-Shaped Flowers

Cylinder and Disk

Most flowers are made up of a combination of basic forms. Once you begin to think about basic forms, you will have little trouble recognizing them in every flower you draw. Daffodils, for example, are formed of a small cylinder occupying the center of a larger disk.

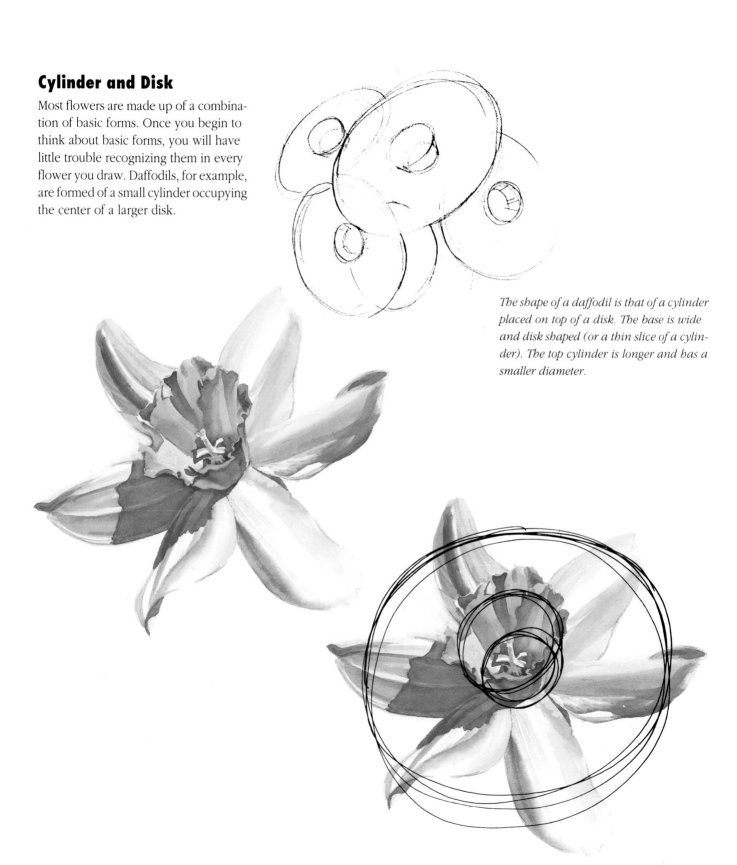

The shape of a daffodil is that of a cylinder placed on top of a disk. The base is wide and disk shaped (or a thin slice of a cylinder). The top cylinder is longer and has a smaller diameter.

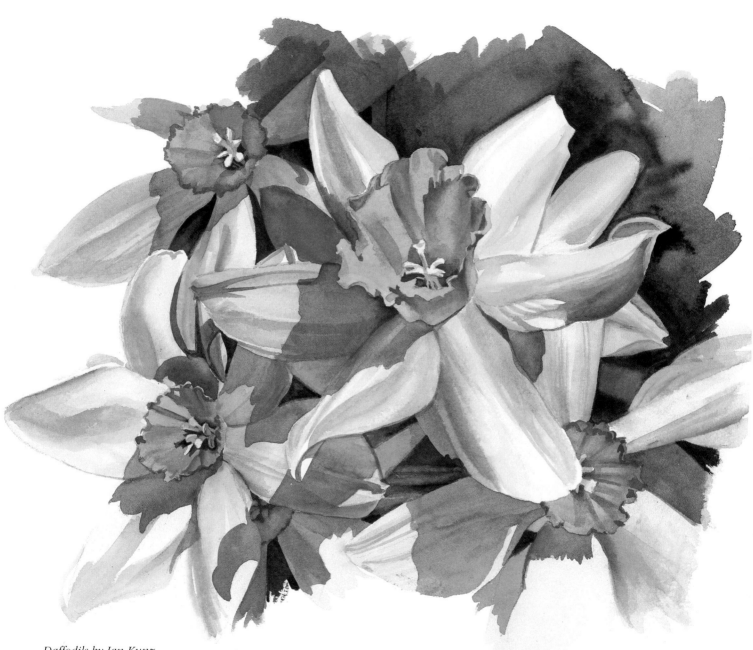

Daffodils by Jan Kunz

Multi-Shaped Flowers

Two Spheres

Irises are also a combination of shapes. Visualize them as two spheres. The top portion of the flower, where petals curl up toward the center, encases the smaller of the spheres; the larger bottom sphere is composed of petals bending back to encircle the stem.

Now you have the idea: Think basic form. Paint any flower you choose—but think basic form first! It has been said that form drawing is fundamental to all art. Become aware of the objects you draw as solid forms having depth.

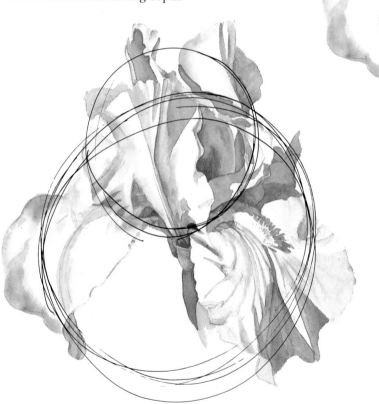

An iris can be thought of as two spheres, one above the other. The cylindrical stem begins at the bottom of the top sphere and is enveloped by the bottom sphere. The bud is ovoid—like a balloon that has been squeezed into an elongated shape. The tip of the bud is located slightly behind the top flower and pushes into the petal above it. Remember to allow visual space for every form in your painting.

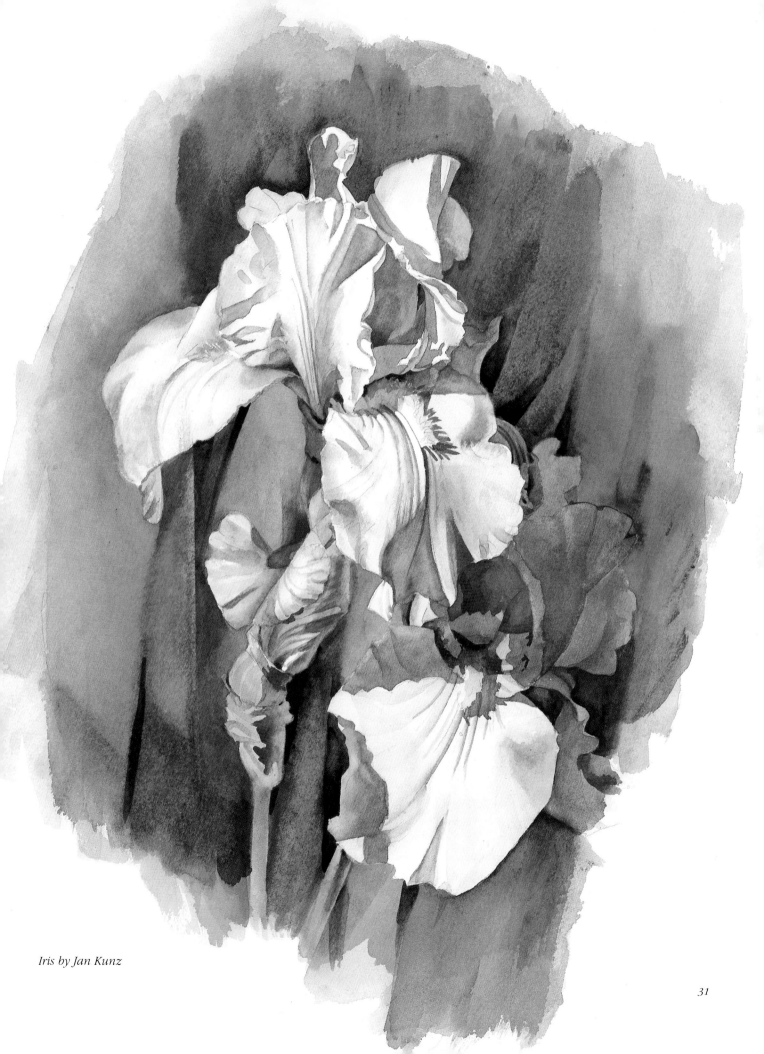

Iris by Jan Kunz

Hints on Texture

Here are a few techniques that can be helpful in capturing a variety of textures. When painting shiny flowers in watercolor, remember to retain white paper to suggest highlights—or resort to scraping, erasing or using opaque white. Textured or ridged petals can best be suggested with three simple washes—a local color wash, a bit of deeper definition and a detail wash. You can carry this as far as you like. When painting flowers with a complex overall shape, try to map out the basic forms. Use value to make sense of the many shapes you see and, again, those same three basic washes can do it all.

Shiny or Matte Surfaces

Iris and roses are among the most popular matte-finish flowers.

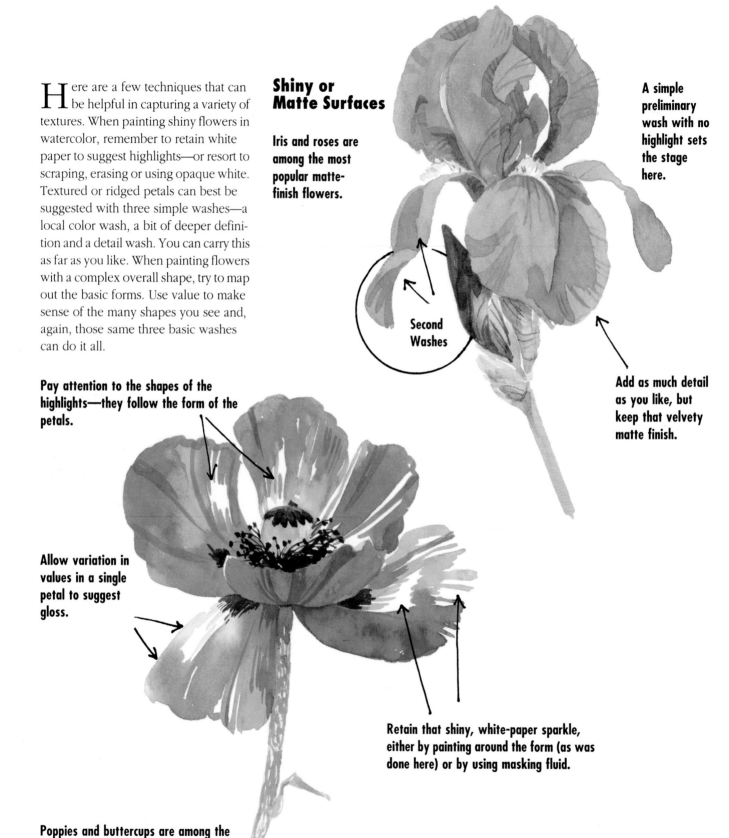

A simple preliminary wash with no highlight sets the stage here.

Second Washes

Add as much detail as you like, but keep that velvety matte finish.

Pay attention to the shapes of the highlights—they follow the form of the petals.

Allow variation in values in a single petal to suggest gloss.

Retain that shiny, white-paper sparkle, either by painting around the form (as was done here) or by using masking fluid.

Poppies and buttercups are among the shiniest flowers.

Complex Petals

Complex flowers include zinnias and mums—and dandelions.

The final washes capture texture, form and shadow—here, violet was used to complement the yellow.

Details add believability and sparkle.

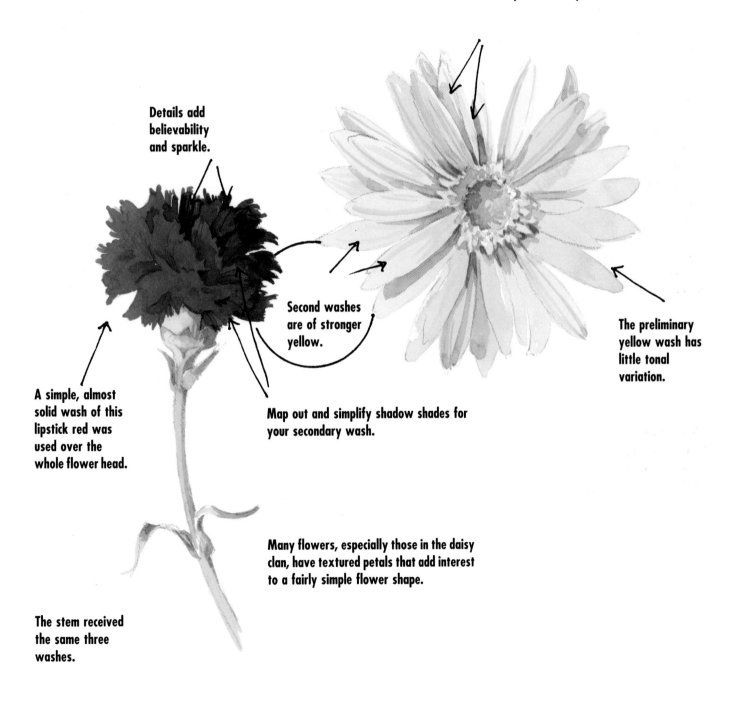

Second washes are of stronger yellow.

A simple, almost solid wash of this lipstick red was used over the whole flower head.

Map out and simplify shadow shades for your secondary wash.

The preliminary yellow wash has little tonal variation.

Many flowers, especially those in the daisy clan, have textured petals that add interest to a fairly simple flower shape.

The stem received the same three washes.

Flowers With an Overall Texture

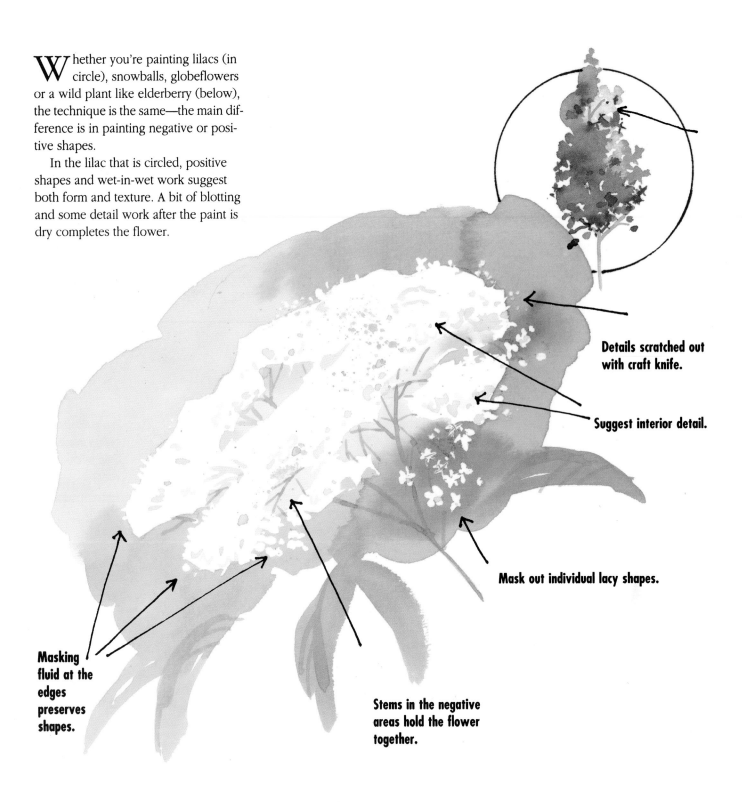

W hether you're painting lilacs (in circle), snowballs, globeflowers or a wild plant like elderberry (below), the technique is the same—the main difference is in painting negative or positive shapes.

In the lilac that is circled, positive shapes and wet-in-wet work suggest both form and texture. A bit of blotting and some detail work after the paint is dry completes the flower.

Details scratched out with craft knife.

Suggest interior detail.

Mask out individual lacy shapes.

Masking fluid at the edges preserves shapes.

Stems in the negative areas hold the flower together.

Flowers in a Field

These may not be daisies; depending on where you are, you may see black-eyed Susans, clover, thistles or Queen Anne's lace. The basic principles are the same—logical shapes.

Spatter of masking fluid or pigment can suggest distant flowers.

Wet-in-wet spatter is softer and subtler (as indicated by the arrow).

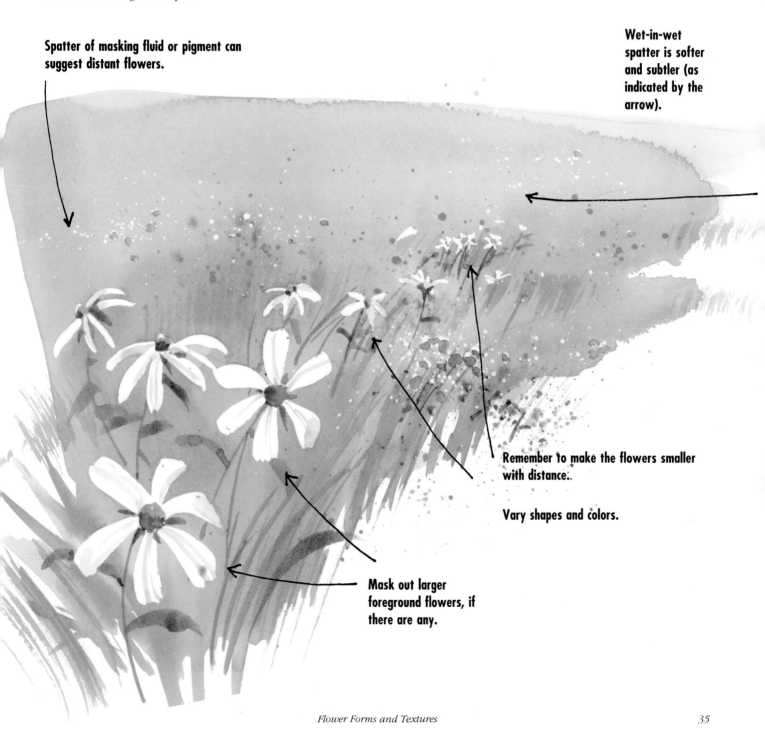

Remember to make the flowers smaller with distance.

Vary shapes and colors.

Mask out larger foreground flowers, if there are any.

Suggesting Form With Line

Line is still another way to suggest surface form. The iris petal appears to curve back, largely because of the vein lines on its surface. A change in color temperature further enforces the illusion. As with everything you paint, observation is the key.

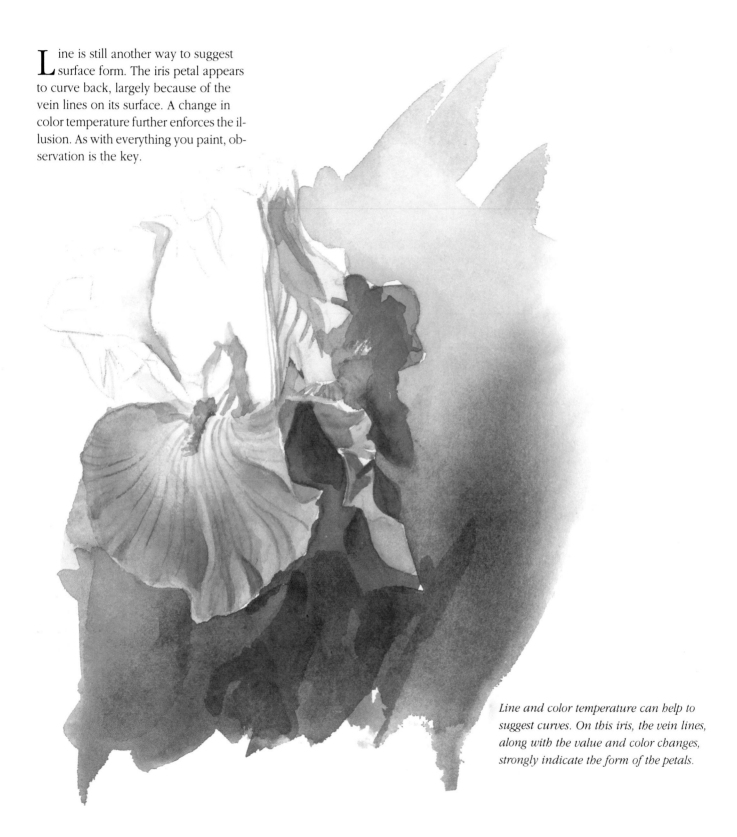

Line and color temperature can help to suggest curves. On this iris, the vein lines, along with the value and color changes, strongly indicate the form of the petals.

Painting Folds and Ruffles

There are several things to keep in mind when painting multiruffled blooms. Not only is the whole flower subject to sun and shadow, but each ruffle and fold moves from direct sun to shade, and then into shadow, many times within one petal. These value changes must be consistent! There are many opportunities to introduce reflected light.

It's easier than you might think to become so intrigued by painting a flower's ruffles and folds that you lose sight of its overall shape. Study your subject carefully. Draw the shadow and highlight shapes. You will probably need to simplify them considerably.

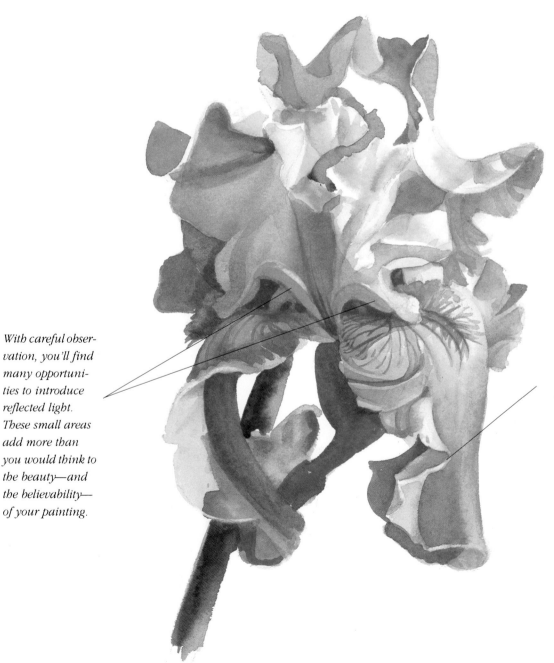

With careful observation, you'll find many opportunities to introduce reflected light. These small areas add more than you would think to the beauty—and the believability— of your painting.

Every petal has dimension: Each has a part facing the light, another facing the sky, and still another in shadow, as well as many areas of reflected light and cast shadows.

CHAPTER THREE

Demonstrations and Special Tips

*Guarding the Daisies, Frank Nofer,
18" × 27½", From the collection of
Dorothy E. Wise*

Basic Flower Painting Techniques in Watercolor

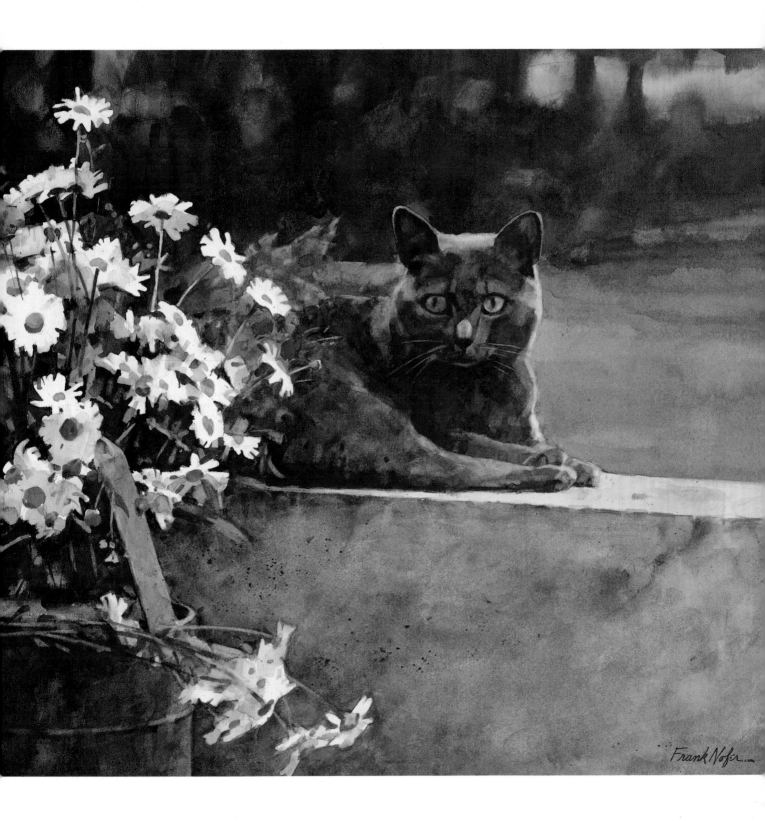

Underpainting Purple Shadows

J udy Treman's paintings are kaleidoscopes of color, shape and detail. They're also very large in scale, with some reaching nearly 4′ × 5′. The secret to pulling off these large paintings is the use of strong values and clear, vibrant colors that pop. Purple underpainting forms the foundation for the crisp layers of brilliant color that follow.

With large-scale paintings, Judy quickly learned that it wasn't practical to add shadows over what was already painted—the colors ran together and created a muddy effect. She needed strong shadows to give depth to a painting while ensuring that the design didn't lose itself in busy patterns. Starting with purple shadows was the solution to her problem.

Establishing Values

The idea of underpainting is to establish the values of the shadows and develop the basic composition.

Graded washes are used in the first layers of purple. For instance, soft, graded edges can create the contours of flowers or the folds of a quilt. When the underpainting is finished, the depths of the design and individual forms are already revealed.

It is a good idea to exaggerate the intensity of the purples and to apply darker values than intended for the finished painting. Watercolors fool the eye, drying lighter and less brilliant than when wet. Darker washes also retain their power and depth when local hues and details are glazed on later. For example, compare the strength of the vase's cast shadow in Step 1 (page 42) with that same shadow in the finished work. The purple looks much stronger standing alone, but melds into the forms when overpainted.

Basic Flower Painting Techniques in Watercolor

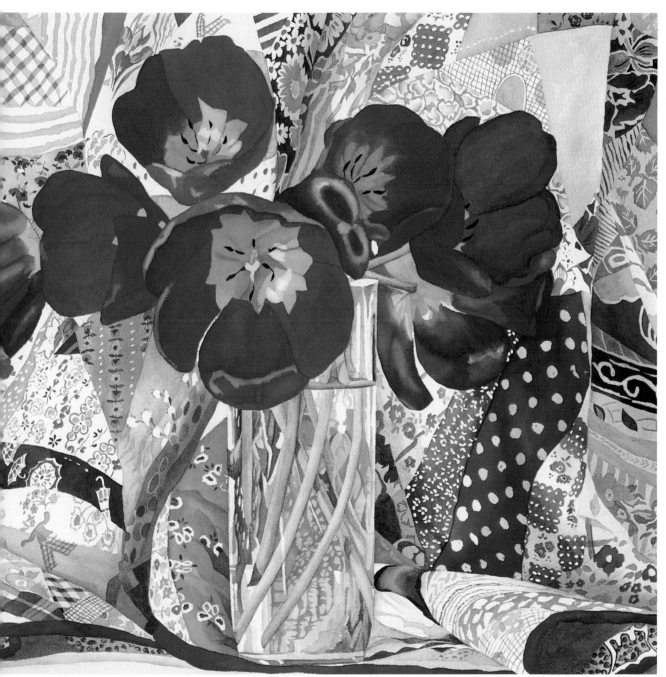

Deep-Purple Secrets *The secret to the depth in dynamic, colorful paintings like* Ribbon Quilt and Tulips *is purple underpainting. Put the darkest values of purple behind the tulips and the extreme foreground of the quilt to make these portions come forward against the cooler, lighter hues in the background. To keep this still life "alive," Treman included areas of red, yellow and green in the quilt both to complement the red of the tulips and make your eye dance between the foreground and background.*

Ribbon Quilt and Tulips, Judy Treman, 20" × 28"

Underpainting Purple Shadows

D E M O N S T R A T I O N

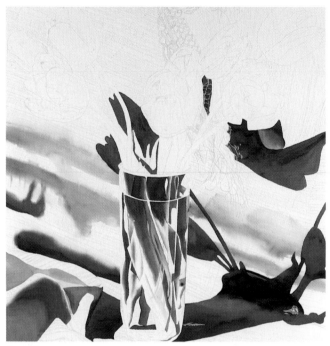

Step One

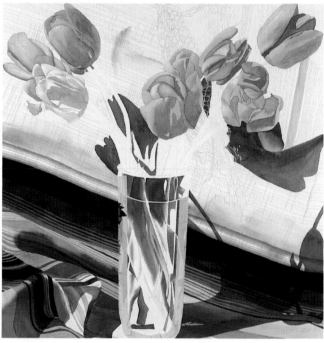

Step Two

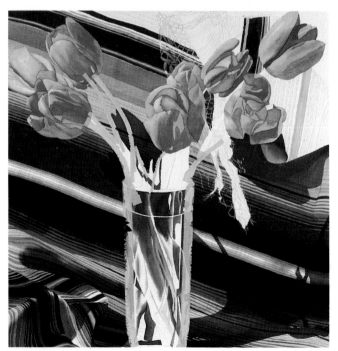

Step Three

Step One: Purple First

Apply masking fluid to preserve areas of white paper from your washes. Winsor Blue/Alizarin Crimson mixtures form the darkest and intermediate shadows. Vary the mixture from cooler (more Winsor Blue) to warmer (more Alizarin Crimson) depending on the local color to come later. Warmer colors in the foreground and cooler ones in the background express depth.

Step Two: Introducing Color

A mixture of Ultramarine Blue and Rose Madder defines the moderate-to-light values that complete the underpainting. Add the first glazes of local color on the serape and tulips: Build all colors from light to dark, using transparent colors wherever possible. Masking tape holds the crisp edges on the vase and stems as color is added around them.

Step Three: Building With Glazes

The purple underwashes begin to disappear as color is glazed over the flowers and the serape, but the strong shadows they produce continue to add depth even as they take on the subtler colors of the overglazes. Notice the shadow to the right of the

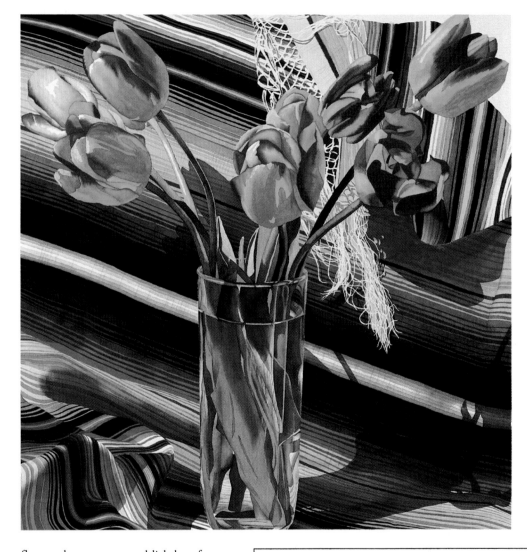

Tulips and Rainbows,
Judy Treman, 39" × 38"

Step Four

flowers has a warm, reddish hue from overglazes of yellow and red, while the shadow in the lower left shows the influence of cooler colors.

Step Four: The Final Touches

Remove the masking tape from the edges of the vase and stems after the stripes of color in the serape are completed. Then finish the masked areas. Removing the masking fluid from the fringe brings out crisp, white accents.

TIP

Any one color you see in Judy Treman's work is actually an accumulation of different colors applied over each other in a succession from light to dark. Instead of trying to paint each strip in the serape independently in a different color—which doesn't lead to a well-blended result—she applies washes of color in wide bands. As the pigments build up, one over another, the intensity of the colored stripes also builds. The yellow stripe, for example, serves as an underlayer for the next-darker stripe—in this case, red. The final glaze was the thin burgundy strip.

More Purple Underpainting

Transformation

This disappearing-purple technique can greatly enhance your watercolor paintings. The underlying purple washes establish the basic composition and value structure and form the foundation for everything that follows. Furthermore, you can have strong shadows underlying vivid colors and details and still maintain a transparent glow from the white paper.

You'll find that as each painting proceeds, what were once strong purple washes become the neutral value statements of the shadows. The final painting has the bright colors, depth, strong design, dynamic composition and convincing realism desired in a work of art. You'd never know it was once awash with purple!

TIP

Treman uses Winsor & Newton series 7 brushes. They hold a good amount of liquid and make a fine point that always puts the paint exactly where you want it.

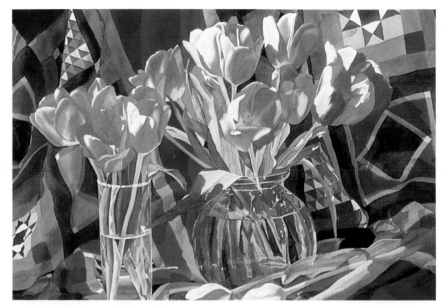

Balancing Depth and Vibrance *The rich, dark colors of the quilt in* Simple Joys— Amish Sampler *result from a very dark purple underpainting (Alizarin Crimson/ Ultramarine Blue/Winsor Blue). Yet Judy wanted the purple applied transparently enough for the white paper to show through. One trick is to make the edges of the shadows darker while washing clear water into their centers. This gives the illusion of dark shadows but lets overglazed colors register more vibrantly.*

Simple Joys—Amish Sampler, Judy Treman, 28" × 39"

Making the Picture Pop *A challenge in* Joyful Faces *was making the pale- and dark-pink dahlias and roses stand out against the complex silk quilt and the shadows from a miniblind. Judy reserved the lightest values for the flowers and put the darkest areas of the quilt directly behind the blossoms, making them pop out. Purple underwashes reinforced the sense of depth, with cooler, darker-hued purples in the background quilt and warmer hues in the flowers.*

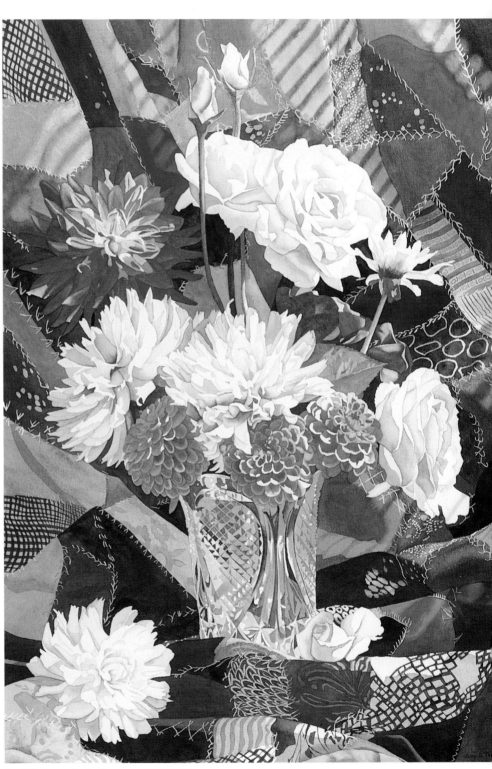

Joyful Faces, Judy Treman, 39" × 27"

Capture the Brilliance of Petals With Glazing Techniques

The luminosity of watercolor seems to be a natural for capturing the iridescent colors of flowers. But single washes, even those composed of several hues and values, can't convey the luminosity or depths of color that exist in flowers. The best way to mimic nature is by building thin glazes of color. These glazes allow light to pass through them, as if through layers of tinted glass, creating brilliant color.

How to Wash Whites *Transparent watercolor glazes gradually brought* White Peonies *into crisp focus. To keep each glaze sparkling, wait until the paper is completely dry before adding more color, and rinse the brushes after each color is applied. Although the flowers were white, much of the petals' area received light glazes to shape them. Sometimes, in the initial phases of light paintings like this, Jean Cole pencils a "w" into the areas to remain pure white. It's always better to err on the side of too much white—you can always paint over it later.*

White Peonies, Jean Cole, 30" × 32"

Basic Flower Painting Techniques in Watercolor

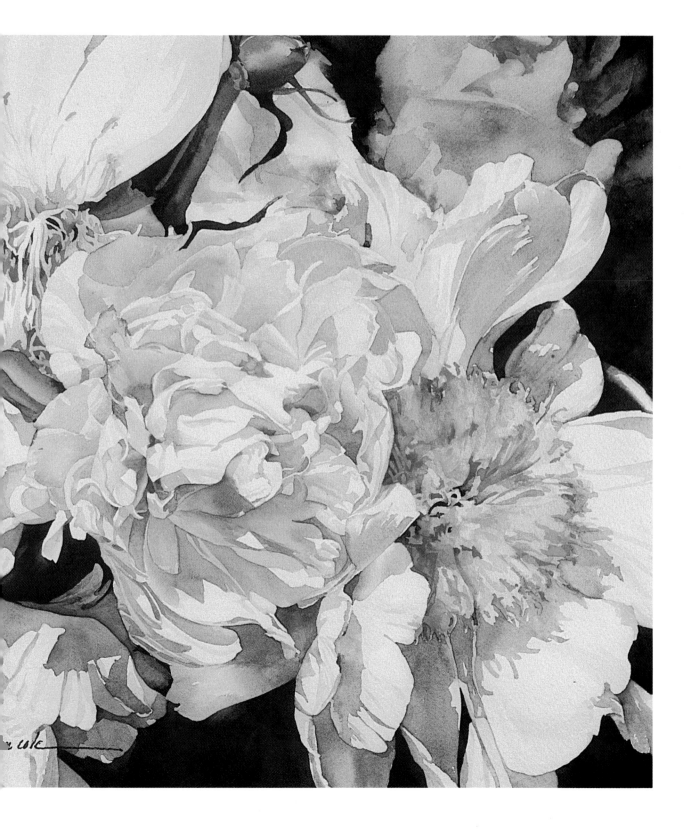

Capture the Brilliance of Petals With Glazing Techniques

Step One: Initial Washes

Include hints of reflected colors and shadows in the initial washes. Note how Jean Cole painted the leaves with blue and yellow and gave the lavender petals an underwash of pink and yellow. Be careful not to cover areas where you want the white of the paper to show through; all other parts of the composition receive toning wash—even areas that hold white flowers. The undertoning color is either the lightest version of a given color or a different color that sets the stage for brilliance later.

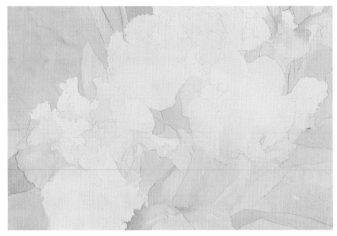

Step One

Step Two: Getting Deeper

Wait until the first washes are completely dry before adding the next layer of color. When it comes to the glazing process, the importance of the word *dry* can't be overemphasized. Note how much some areas were darkened once Jean came back with Permanent Rose, Cobalt Blue and Phthalo Purple. A minimum of three glazes is usually needed for a three-dimensional effect (one each for the lights, middle tones and darks).

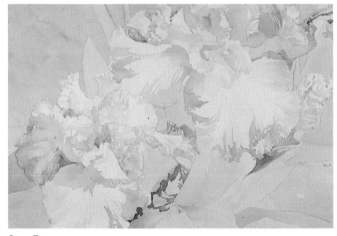

Step Two

Step Three: Finding the Nuances

Gradually deepen the values in the painting by building the ruffled forms of the iris. Pay attention to the nuances of color running through the shapes and shadows. Here, Jean used Hooker's Green and Winsor Blue in addition to the deeper Cobalt Blue and Phthalo Purple.

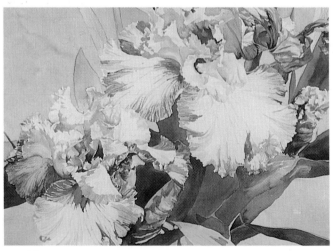

Step Three

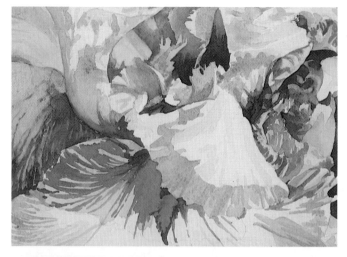

In Detail *Close up, you can see how Jean painted the striated purple detail first and allowed it to dry completely. Then she went over it with a mixture of Phthalo Blue, Aureolin and Permanent Rose to put it in shadow. This way, the detail lines were softened and subdued, as if seen in low light. Had she wanted those lines to dominate, she would have put them in last.*

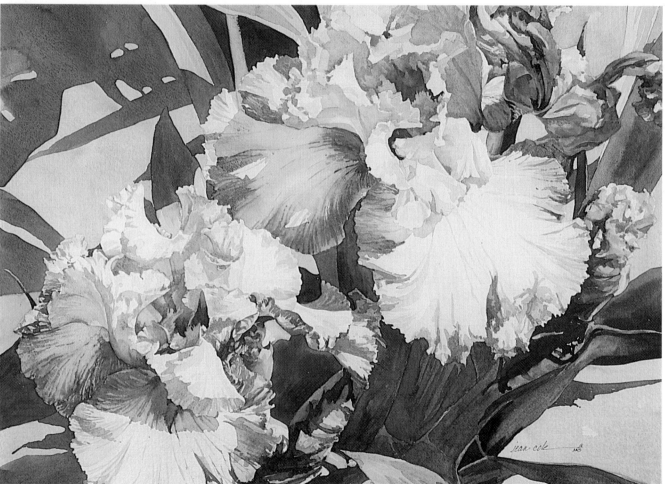

Lavender Blue, Lavender Green, Jean Cole, 22" × 30"

Step Four

Step Four: The Final Wash

In the final step of Lavender Blue, Lavender Green, *Jean finished the shadows on the flowers and the cast shadows in the background. Although painted with a single-layer wash, the shadows aren't a single color, but change as they move across the background space.*

More Techniques With Luminous Glazes

Developing the Drama *Impact is created by increasing the area that the flowers consume—Cole aims for them to cover at least 50 percent of the page. Then she concentrates on the abstract patterns of shapes and shadows. Adding to the punch of* Evening Primrose *is the dark background, which was applied after the petals were rendered. This way, there was no risk of any background color seeping into and muddying the petals.*

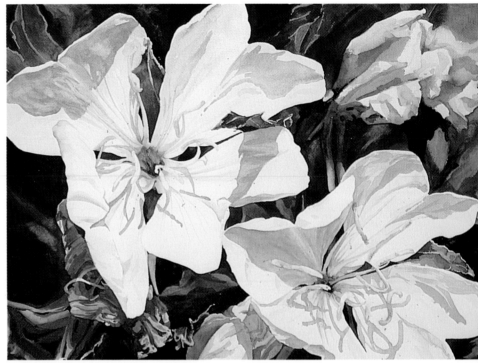

Evening Primrose, Jean Cole, 22" × 30"

Starting Warm, Ending Wild *Cole gradually built all the colorations in the variegated leaves and suggested their highly reflective surfaces with glazes. Keeping in mind that the application order can dramatically change the look of the end product, she began with a warm yellow wash here. The spots were painted with green and Phthalo Blue. By alternating cool and warm washes, a vibrancy was achieved that wouldn't have existed otherwise. Alizarin Crimson washes were applied to the variegation near the end of the process to define the veins and give the leaves their red tones.*

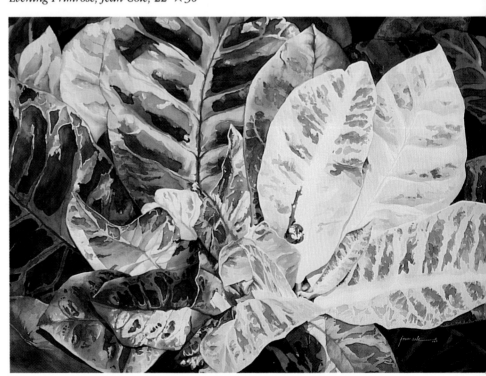

Variegatum, Jean Cole, 32" × 45"

Basic Flower Painting Techniques in Watercolor

KEYS TO CLEAN, SPARKLING EFFECTS WITH LUMINOUS GLAZES

- If a color is glazed over the same color it will become twice as dark.
- If one color is glazed over a different color, it will either create a grayed version of one of those colors or a third, entirely different, color.
- The sequence of colors determines the hue we perceive. For instance, blue glazed over an orange underwash will produce a grayed orange, but if the orange goes over the blue, the result will be a grayed blue.
- Alternating cool and warm washes creates a vibrating effect that cannot be achieved by simply mixing the two colors.
- The final color is affected by the amount of pigment used and the value of the washes. Opaque paints, such as Cadmium Orange, should be mixed with more transparent pigments or be used thinly to keep from "killing" the undertones. The best glazes are produced with transparent, nonstaining pigments such as Aureolin, Cobalt and Viridian. Use care when using a staining pigment such as Alizarin Crimson—it can soak through a number of washes and destroy the layered effect.
- Take care not to overmix your glaze colors or you'll end up with dull, neutral tones. Also, try for a combination of hard and soft edges when applying a wash.
- Keep the colors of your overwashes as fresh and clean as possible. Rinse your brush before putting it into another color. This keeps the colors on the palette pure and prevents unexpected mixtures. Some artists keep two quart jars of water within reach so they always have clean water.
- Keep a rag or facial tissue handy to control the water on the paper as well as on the brush. The tissue can be used to mop up mistakes.

Create Velvety Images With Cotton Swabs

Photorealism can sometimes be so real—so hard-edged—that it loses its appeal. Mary Kay Krell prefers paintings that can be lived with, so she softens the blows of reality. Using homemade watercolors and cotton swabs, she tempers realism to create a soft, luminous look and a plush, almost velvety, richness. Most of the process is a matter of applying, then lifting, color.

Krell's paintings are careful, methodical, well planned and well drawn. Her advance preparation includes choosing subject matter and photographing it.

First Blush

Once decisions about the piece are made, she draws freehand on Arches 300-lb. cold-pressed paper with a 5H or 6H drawing pencil. She's not too concerned about keeping the paper immaculate, and uses a kneaded eraser often to get the right line. Once the drawing is done, she begins painting without stretching or tacking down the paper.

Krell first lays in the color that glows from underneath (for instance, Naples Yellow is indispensable for a first warm glaze on flower petals), working first in one area, then another, very slowly covering the paper. Later glazes proceed the same way. With a flower, it's one petal at a time, after an initial pale glaze of color. Using a hair dryer after each layer speeds the process.

Lift and Soften With Cotton Swabs

After applying the paint, however, she frequently lifts it. Attempting to create the soft glow of light led to the use of cotton swabs as a major tool for this lifting. She uses swabs all through the process, wetting the cotton, blotting it on a paper towel, and rubbing gently to lift paint on the lighter side of a petal or on the highlights of a piece of glass. For a softer effect, use swabs when the paint is wet; they can also be used to create a more definite effect when the paint is dry. They're good for softening detailed brushwork on cloth or lace, as they create a very convincing texture. Krell acquired this technique early on, after becoming frustrated with the clumsiness of a sponge or a wadded-up paper towel. Though brushes are her primary tool, she can use as many as 300 cotton swabs in a single painting.

In using the swabs at any stage, the key is being gentle. You must avoid stressing the paper when there are additional glazes to apply.

Winter Blooms, Mary Kay Krell, 22" × 30"

Gaining an Edge With Softness *Photorealistic work can look harsh. To give a softened, velvety feel to her work, Mary Kay Krell uses grainy homemade watercolors and softens edges with cotton swabs. Winter Solstice (below) required an enormous number of cotton swabs—maybe two boxes—to lift color and capture the light coming through the lace at a late-afternoon angle. In Winter Blooms (right), she also used cotton swabs throughout the piece. She was careful to balance the yellow throughout so the pears wouldn't topple the color scheme.*

Winter Solstice, Mary Kay Krell, 22" × 30"

Basic Flower Painting Techniques in Watercolor

Create Velvety Images With Cotton Swabs

DEMONSTRATION

Step One

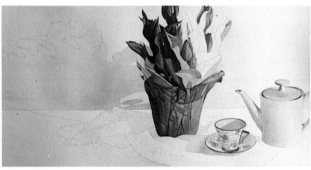

Step Two

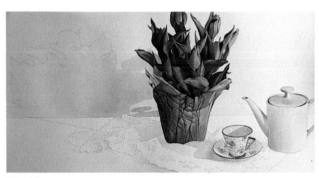

Step Three

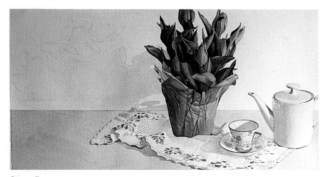

Step Four

Step One

A Blush of Color

Wet the background, then paint with a large, flat brush, keeping the color smooth and uniform. The natural graininess of hand-made paints automatically softens those areas.

Step Two

Enrich the Details

To add richness, detail the irregularities in the pot with cotton swabs, and exaggerate the color differences in the leaves. Use a blue wash for the lightest areas; do details and areas of depth with yellow-greens or orange-greens. Enhance shadows with neutral tint and violets.

Step Three

Control the Values

Continue building the color slowly, controlling the values. Glaze more layers over the table so it will be warmer in hue and darker than the background, thereby holding the objects in the still life together. Use a gray composed of Neutral Tint, Cobalt Violet, Cerulean Blue and Ultramarine Blue on the table surface.

Step Four

Deepen the Shadows

Use the same gray mix as on the table surface and paint the shadowed areas on the cloth, table and background. A second wash of Neutral Tint darkens the background shadow. The Neutral Tint subdues the color when necessary, yet colors from underglazes show through it because it has no color of its own.

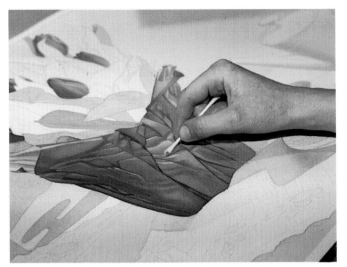

Detail: Lifting the Lights

To build the contours of the tulips and the flowerpot covering, use glazes of Cobalt Violet mixed with Cadmium Red, Vermilion and Cadmium Orange. While damp, gently begin wiping out highlights with wet cotton swabs.

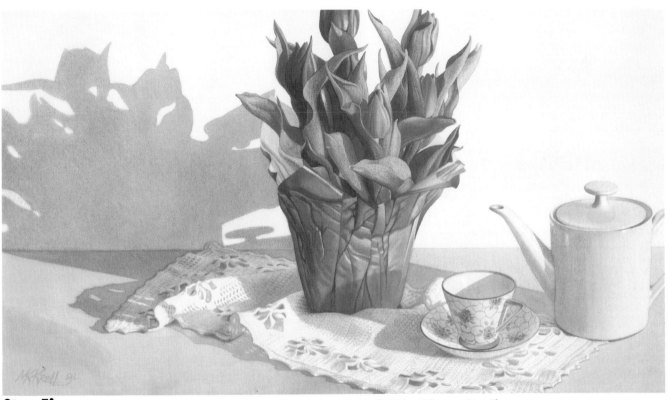

Step Five

Opening Act, Mary Kay Krell, 22" × 30" **Step Five**

Adjust Values With Pigment and Cotton Swabs

At this point Krell decided that the shadow area on the left side seemed too empty and uninteresting, so she cropped four-and-a-half inches off the left side of the painting. Then she applied pink wash over the table surface to intensify and unify the shadow areas. To finish, soften any harsh edges around the shadows, cloth and leaves with cotton swabs.

HOMEMADE WATERCOLORS

The velvetiness in Mary Kay Krell's paintings is partially due to the watercolors she makes from dry pigment mixed with water, glycerin and gum arabic. She decided to make them because it was more economical than buying paint in tubes. Now, she prefers the dense, vibrant colors and the grainy, velvety textures. It's somewhat like working with pastels.

The basic recipe is simple—powdered pigment, water, vinegar and gum arabic—but the amount of each ingredient varies with each hue you're mixing. Most powdered pigments are hazardous to your health, and certain precautions must be observed in handling them.

Create Velvety Images With Cotton Swabs

Making It Work, Effortlessly

Balancing composition and color is a challenge in painting, and these two pieces were no exception. In *Rose Legacy*, Krell wanted to show both the flowers outside and those inside. The painting is almost cut in half—a compositional no-no, but it works by using the same colors in both the indoor and outdoor scenes. In *Marjorie's Mirror*, the unconventional angle interested Krell, and she liked the idea of painting the still life as a reflection in the mirror. The lilies, however, were a challenge, since she leaves no bare white paper in her paintings; she built them up with pale washes and used cotton swabs to life the color in some areas.

Finish With Cotton Swabs

One of the last steps in almost every floral painting is to soften the edges around the flowers and objects in the foreground. Because background washes are usually put in last, the paint often pools around previously painted edges. To soften these, gently rub with damp cotton swabs. In darker paintings, this can create a subtle atmosphere of depth, as if the air had color density. Again, in using the swabs at any stage of a painting, the key is being gentle.

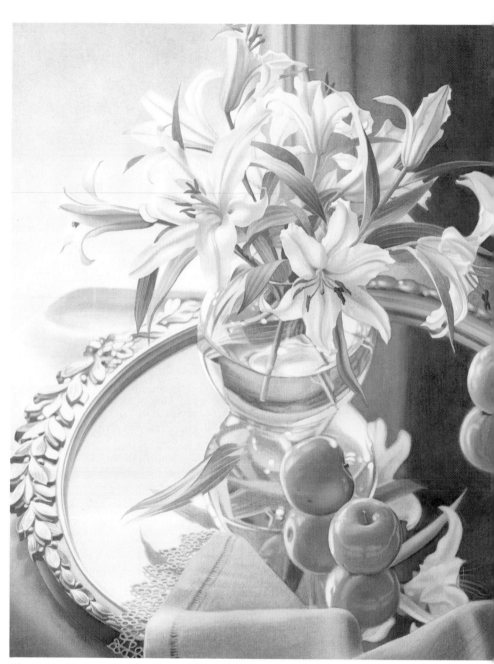

Marjorie's Mirror, Mary Ann Krell, 22" × 30"

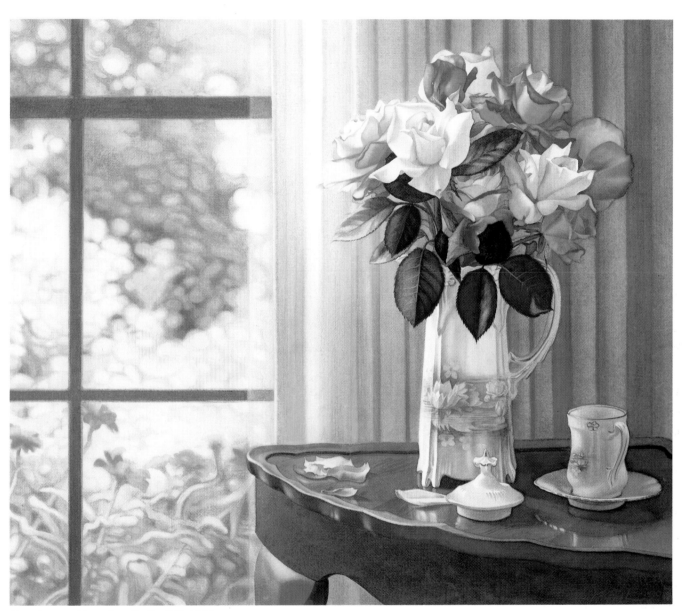

Rose Legacy, Mary Ann Krell, 22" × 26"

Amaryllis in Action

DEMONSTRATION

Most artists like still lifes because the subjects under scrutiny always remain still. For Anna B. Francis, however, this is a disadvantage. She works better with time pressure. She likes to create an atmosphere of urgency by choosing as subject material perishable objects that change rapidly. This forces her to work fast and to imbue the objects with life.

Like most artists, she uses a whole range of methods and techniques in drawing and painting. And the best way to show this rapid approach is to have you look over her shoulder as she works.

Step One

Start with a two-minute, "sloppy" sketch to get a feel for the subject and the composition. At this stage, a neat or careful drawing could foster stiffness or a static composition Use a 5B or 6B pencil for this sketch.

Step Two

Look at the drawing over your shoulder using a hand mirror, to see it in reverse. By doing this you may find, for example, the flower on the left looks too big (or the one on the right is too small). Use bond layout paper to do an overlay and make changes. You can remove the bud on the left, add a bud on the right for balance, and make the blossom on the right larger.

Step Three

Many times something in the composition will still not look right. You can turn the board upside down on your easel to get another point of view. This forces you to forget the subject so you can focus on the composition.

Step One

Step Two

Step Three

Night Light, Anna B. Francis, 29" × 20"

Basic Flower Painting Techniques in Watercolor

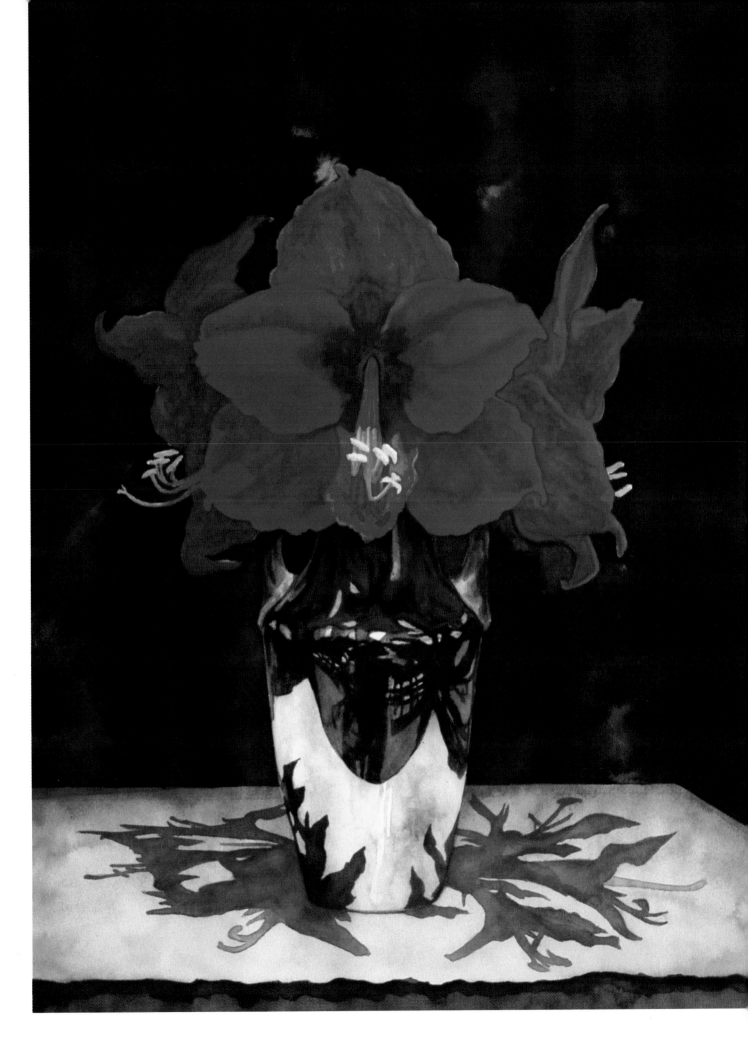

Amaryllis in Action

D E M O N S T R A T I O N

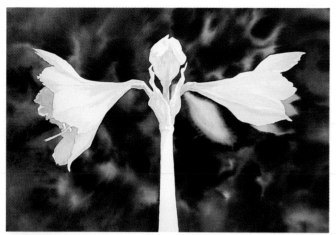

Step Four

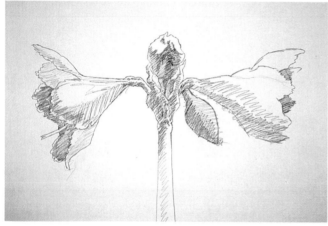

Step Five

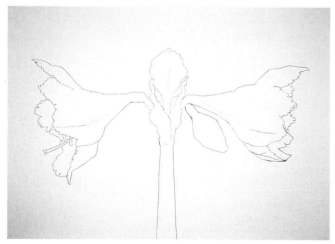

Step Six

Step Four

Around the Subject

To get a feel for how the space around the subject is working, do a black-and-white watercolor sketch. Watercolor is much faster than filling in the space on the drawing. The large areas of negative space are very important to the composition.

Step Five

Another Sketch

At this point, check your composition to see if you're happy with it. If you're not, make another drawing, placing bond paper over the sketch to keep the parts you like.

Step Six

Transfer the Drawing

Use a light table to transfer the drawing to watercolor paper. Resist the urge to render details; work fast. This keeps energy in a still life.

Step Seven

Wet-Into-Wet

Wet the bud with a light, Cadmium Yellow Medium wash, then drop in Permanent Rose and a mixture of Winsor Yellow/Prussian Green. The colors mix on the paper. It's a basic wet-into-wet technique.

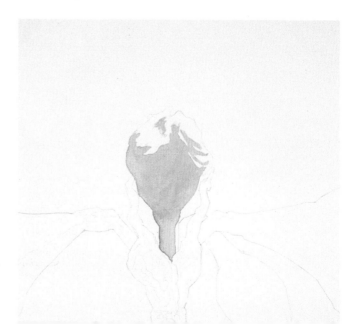

Step Seven

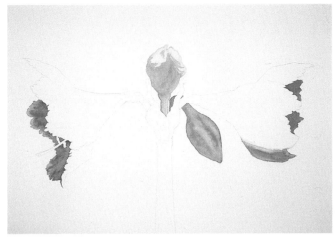

Step Eight

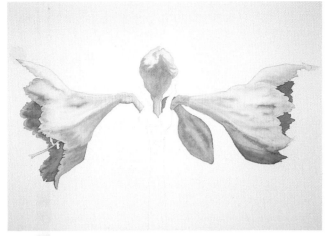

Step Eight

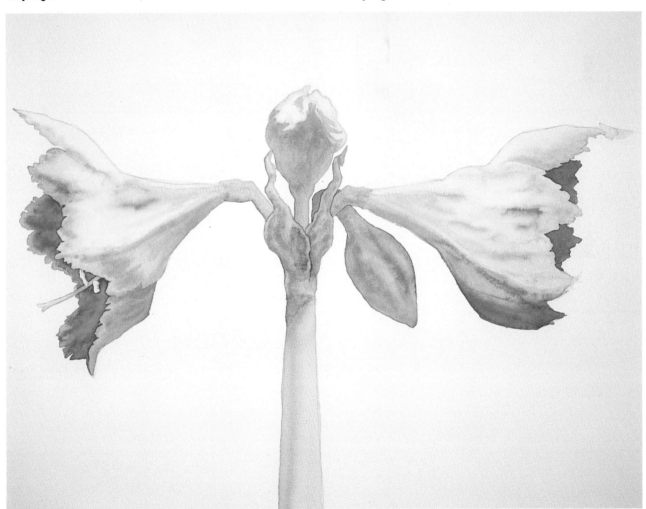

Step Nine

Step Eight

Bring Out the Blooms

Paint the other bud and begin working on the blooms. Be careful when working wet-into-wet because you can't paint shapes next to each other while they're wet or they'll melt into each other. A blow dryer speeds up the process. Finish this stage by painting the outer petals.

Step Nine

Complete the Subject

Paint the stem after the shapes are dry. Dampen the back with water, let it sit for 20 minutes, then staple to a gessoed board to stretch.

Amaryllis in Action

DEMONSTRATION

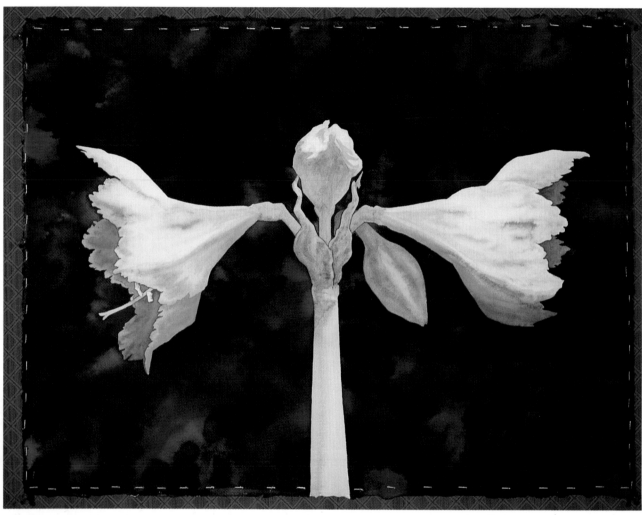

Step Ten

Step Ten

Finish

Before painting the background, the amaryllis must be completely dry. The paper must also be stretched and stapled. The 300-lb. paper will not buckle as much as the 140-lb. paper. Start in the lower left by wetting a large portion of the white background area with a cellulose sponge. Areas adjoining amaryllis are moistened with a large brush. The paper should only be damp enough to glisten slightly. Allow droplets of pigment to flow from the tip of your brush onto the wet surface. Carefully manipulate the pigment only where it touches the blossom or stem. Soak up excess pigment and water with a slightly damp brush. Continue the background, working clockwise until it's completed.

*Perseverance, Anna B. Francis,
21½" × 29½"*

Basic Flower Painting Techniques in Watercolor

Step Three

Giving Blush to the Blossoms

Block in the blossoms and stems, adding greens and reds. For soft edges in the blossoms (where they fade from red to white in the detail, for instance), paint the area with clear water first. Then paint the harder edge on dry paper and carry the paint into the damp paper, allowing the water to fade the edge. To complete the painting, additional glazes push the background away and make the petals appear to advance in space.

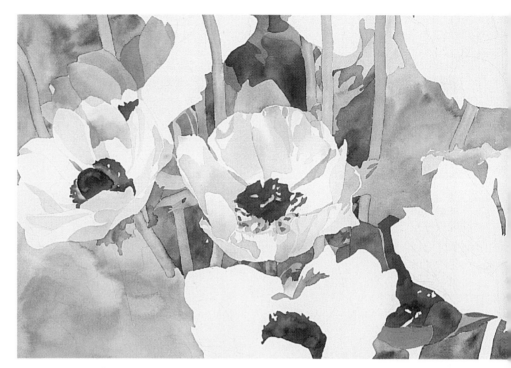

Anemone Festival, Marilyn Schutzky, 22" × 30"

Painting a White Blossom

Promises, Promises, Marilyn Schutzky, 29" × 41"

Shadows

When Marilyn Schutzky paints a white blossom, as in *Promises, Promises*, she starts with the shadows, using very light gray washes on dry paper (when the blossom is another color, the shadows carry that color). Keeping these washes light allows the blossom to come forward in space—the deeper the wash, the more it will push back in space. Since the apple blossom in that painting has some pink in it, she very lightly dropped in pink, then added violets, Cerulean Blue and other hues for variety and movement.

When these colors splash into the wet grays, they react in various ways. They fuse and separate in a color dance, forming a host of visually exciting areas. Schutzky comes back to the flower when it's dry and lightly glazes another shadow layer to define the contours, edges and deeper shadow areas.

Background

For the background, float on a dark value. The value must be deep—maybe an eight or nine on the value scale—because the next step will lighten it. This darker wash makes an area appear to push back in space, allowing the flower to push farther forward.

Each time you reach for fresh paint, vary the color. Just as the glisten is leaving the paper, brush clear water vertically. The paint on the paper pushes away from the water, leaving wonderful shapes, blooms and variations that give a hint of what's behind the blossom.

Darkest Shadows

With the shadows and background suggested, the next step is to paint the darkest shapes. This gives a point of reference for the whole painting.

To get luminous, rich and interesting darks, use the staining colors—Winsor Blue, Red, Purple and Green, New Gamboge, Prussian Green and Permanent Violet.

It's very difficult to get full-intensity darks with one application; Schutzky usually glazes over the area again when it's completely dry, using the same colors and techniques.

Soften Edges

Once the painting has started to pull together, begin softening edges. This keeps the subject from looking like it's cut out and pasted on. Use a small bristle brush to dampen and lightly scrub the edges, then a tissue to blot them. A light hand is important—this is easy to overdo.

The Awkward Stage *Soon after roughing in the large shapes, there comes a time in most paintings when the work looks like it's ruined and will be impossible to pull together. This could be called the awkward stage. An example of an unfinished stage of* Tulip Passage *(top) displays this awkward bridge between an exciting beginning and a satisfying finish.*

Since most paintings seem to go through this stage, don't give up—just keep working. Glaze over sections to tie areas together or deepen the richness and depth of the colors. By glazing the shadows in the blossoms, Tulip Passage *began to take form (above). The background at the top of the painting was glazed so it appears to push behind the leafy area on the right. Each leaf came forward as the area around it was painted deeper. Suddenly everything worked!*

STEPPING BACK

Stepping back to view your work is as important as all the brushwork and planning. Do this at least every half-hour—more often when big changes are occurring. You can tell early in the process if things are reading right; passages you love up close don't always carry into the design and may have to be sacrificed for the total picture.

Batik-Like Effects With Crumpled Paper

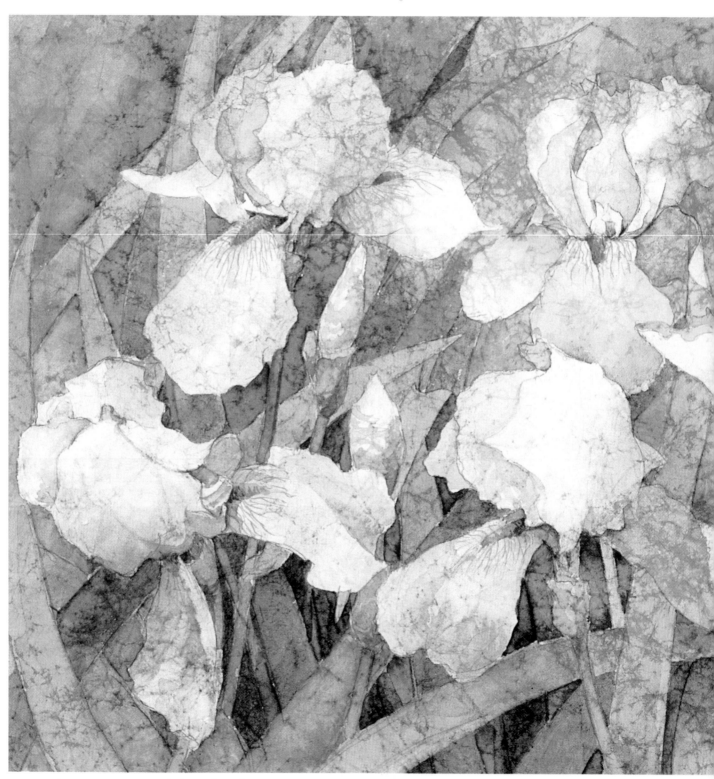

Perennial Beauty, Mary Ann Clarke, 10" × 13"

Basic Flower Painting Techniques in Watercolor

When watercolor seeps into the folds of crumpled Japanese paper, it almost moves on its own into the veins and forms of flowers. The wrinkles hold pigment and fracture the light in a way that gives the painted paper a soft, batik-like look. The first time Mary Ann Clarke painted on this paper, she saw that the result was just what she had been seeking to describe the delicate nature of flowers.

Japanese Masa

For this work, masa (a neutral-pH, machine-made paper manufactured in Japan) is the paper to use. It's soft, white and absorbent, and has a smooth side and a side with slight tooth. Its strength and versatility lend it well to the wetting process.

To prepare the paper, choose a piece of masa and a piece of watercolor paper in a size that you find comfortable.

Crumple the masa, place it in a container of water, and allow it to become completely saturated, which should take only a few minutes. Remove it from the water and squeeze it gently. As you carefully open it, notice the crinkles; if it's not as creased as you would like, squeeze it again, more tightly this time. Take the utmost care as you reopen it so the paper doesn't tear—it's very fragile when wet.

If you prefer to crinkle the paper only in some areas, lay it flat and spray both sides of it with water. Allow it to sit until saturated, then crumple the areas you want to texturize.

After crumpling, place the wet masa on a drawing board and stain it with watercolor. Use a large brush and stain it according to a subject you already have in mind, or randomly brush color onto the paper and allow forms to suggest themselves to you.

No-Wax Batik *Japanese paper and watercolor paint are all that's necessary to create the effect of batik. The way that the pigment seeps into the folds and the way the light is diffused perfectly describes the delicacy of flowers. Clarke usually paints the background washes first, leaving blossom areas white. In* Perennial Beauty, *however, she allowed the petals to overlap the background. This gave them a transparent look and enhanced their fragile quality.*

Batik-Like Effects With Crumpled Paper

Adding Support

Since masa is so fragile by itself, it must be attached to another support for additional painting. Some artists mount it to illustration board, but then the board has to be countermounted to prevent it from buckling. Clarke attaches the masa to a sheet of Arches 140-lb. watercolor paper.

Since color soaks through the paper onto the support, it's best to use a second drawing board to lay out the watercolor paper. If your drawing board (Masonite or Plexiglas) is about one inch wider than the paper, you can hold the paper down by placing clips around the edges.

Lay out the watercolor paper and prepare the glue. Clarke uses Elmer's School Glue thinned slightly with water. Brush the glue onto the watercolor paper, making sure the paper is completely covered. A wide, white sable brush is effective for this.

Place the wet masa over the glued surface and smooth it down with a clean, wet, wide brush, beginning in the middle of the paper and working toward the edges.

Tension Resolved *The way the washes have seeped into the wrinkles of the paper creates an overall softness in* Pink Petunias *that weaves the subject into background. This fusion overcomes the tension that's usually created by placing complementary colors—pink and green in this case—in close proximity.*

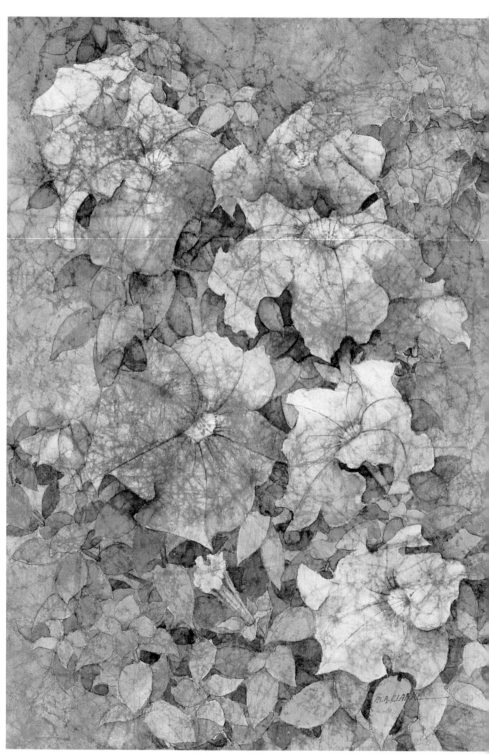

Pink Petunias, Mary Ann Clarke, 13" × 10"

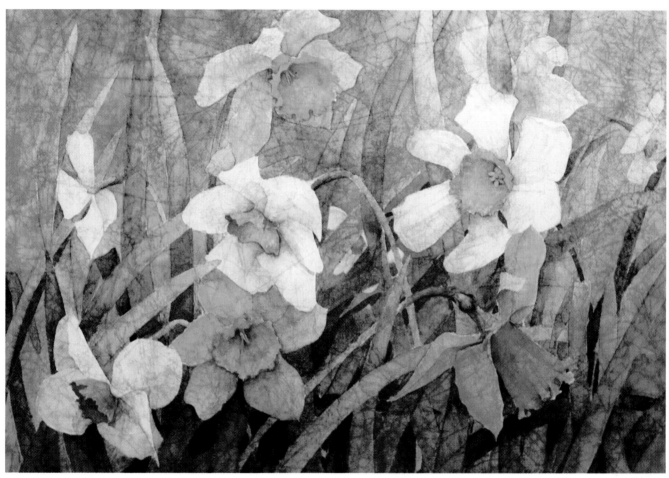

Daffodils, Mary Ann Clarke, 15" × 22"

Focusing the Subject

Evaluate the designs already in the masa and then either draw your composition over them or add paint in an abstract manner. Even if you have a specific subject or composition in mind, be prepared to alter it at this point, because the creases of the paper may have broken up the paint in unexpected areas.

All buckling can be removed at the end of the process. Evenly wet the back of the paper with clear water. Turn the painting right-side-up and allow it to sit for a few minutes. As the paper begins to curl, tape the edges with masking tape—it will flatten out perfectly as it dries. When it's completely dry, carefully take up the tape—it will peel the masa surface if not removed gently. Then you're ready to wrinkle another piece of Japanese paper and take advantage of the luminous possibilities that unfold.

A Spring Moment *The ethereal look of the veined washes is perfect for capturing short-lived spring blossoms such as daffodils. The way that the crumpled paper holds paint and fractures the light adds depth to the rich background colors. Against these dark shapes, the light flowers seem to spring forward in space, adding life and believability to the work.*

Batik-Like Effects With Crumpled Paper

Step One

Crumple the Paper

Begin by wrinkling the whole sheet of masa. Before crumpling it, mark the toothed side with a small *x*; that's the absorbent side and will take the stain the best.

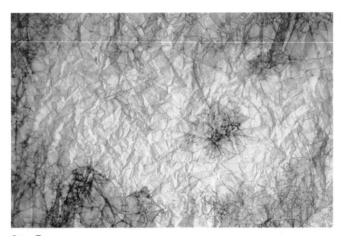

Step Two

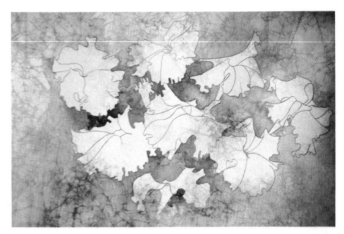

Step Two

Add Background and Flowers

After soaking the masa in water, unfold it and begin to apply stain, leaving white for the petunias (above left). Glue the masa to the watercolor paper, blotting it to eliminate bubbles. Then draw the flowers onto the masa (above right). Begin to define the shapes of the flowers by adding dark, negative shapes (right).

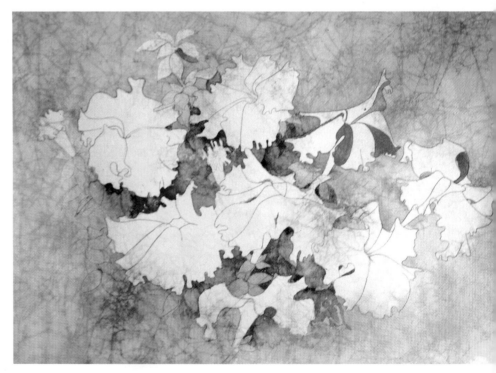

Step Three

Finish With Definition

Bring the flowers to life with the stripes (right). At this stage Clarke still wasn't satisfied with the composition created by the flower at the lower center, so she enhanced the foliage and the play of red against green, painting over the unwanted blossom with Sap Green. The residual red in the petal created a surprisingly vibrant bit of foliage in *Striped Parasol*.

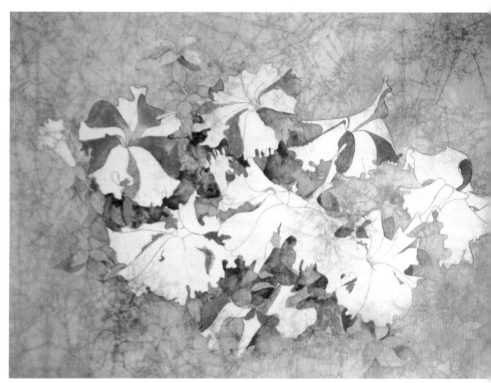

Step Three

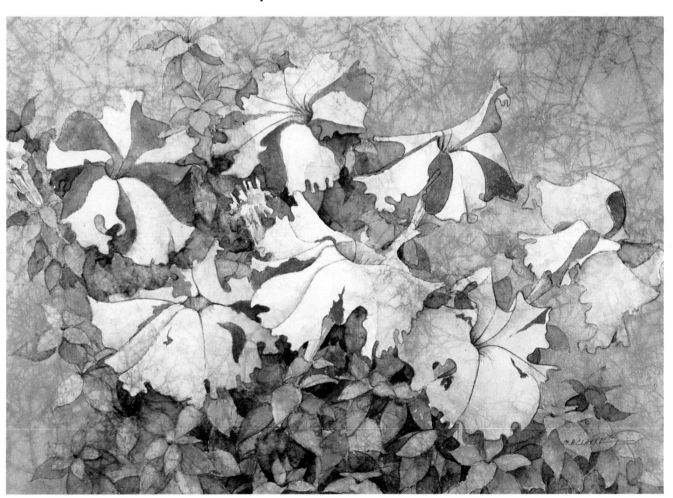

Striped Parasol, Mary Ann Clarke, 10" × 13"

Glazing With Acrylics

DEMONSTRATION

A number of contemporary artists are trading in their watercolors for acrylics—or at least a few select tubes here and there. Acrylic paint is probably the most versatile form of color made today.

When acrylics first came onto the art scene, they were touted as an economical water-based substitute for oils; but acrylics more closely resemble watercolors than oils in their working characteristics. Just squeeze a dollop of acrylics from the tube and mix it with a fair amount of water and you'll create a wash with much the same qualities as watercolor. You can mix washes in a great range of colors and values, and the tinting strength and transparency of acrylics is excellent. When a wash of transparent acrylic is applied to paper, it soaks into the fibers like watercolor or dyes and dries into a nearly waterproof film, making it extremely durable and permanent.

EXCELLENT REASONS FOR USING ACRYLICS.

- With transparent acrylics you can glaze over and over because the washes stay put; you can scrub on additional glazes (subsequent washes) without disturbing the underlying paint layers.
- Because of this strong adhesion of acrylics to paper, you can build up wonderfully deep, rich darks by applying glaze after glaze of color.
- Like watercolor, transparent acrylics can be lifted from the paper while wet. If allowed to dry, they can be partially lifted with the aid of a short bristle brush, water, and a paper towel for blotting.
- If you're patient, you can white out an area with white acrylic and repaint it so that even the most critical eye will have a tough time spotting the reworked area.
- You can resoak and restretch the finished painting to achieve a perfectly smooth paper surface for matting and framing.
- On the practical side, acrylics can be cleaned up from a porcelain tray with a little hot water and a sponge. And the big tubes of acrylics go a lot farther than those little tubes of watercolor!

Because acrylic washes dry to a water-resistant film, you can build up numerous layers of color to slowly deepen the value and intensity. Here, ten layers of the same watery acrylic wash has been overlapped to demonstrate this buildup.

You can create the same luminous, transparent glow that you get from watercolors by glazing with acrylics, which is also easier to do. This technique is especially useful for depicting sunlight through flower petals.

Step One

Underpaint with watery acrylic washes. The underpainting redefines the basic drawing, outlines the foreground areas (as well as those areas which remained white), and blocks in the background color shapes.

Step Two

Build up the background reds by glazing over the underlying yellow and orange washes. Paint the dark shapes into the reds, maintaining soft, transitional edges by first rewetting the reds. Remember: With acrylics you can rewet time and time again without disturbing the underlying work.

Step One

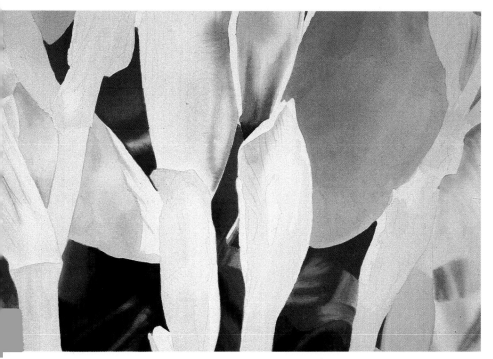

Step Two

Glazing With Acrylics

DEMONSTRATION

Step Three

After establishing the brilliance of the background reds, proceed with the purple petals. Retain some pink wherever you think the red poppies could be seen through the transparent purple petals of the iris.

Step Four

To do all the linework in the calyx, bud and petals, incise the paper with a knife and allow the pigment to float into that line to delineate shapes.

BUILD UP DARKS WITH ACRYLIC GLAZES

With acrylic glazes you can build up your darks in two effective ways.

1. Mix a wash of the exact color you want on your palette, then apply numerous glazes of this wash until the color and value reach the desired depth.
2. Break down the color into its component parts—for instance, yellow and blue to produce green. Simply apply one wash of pure color over another; each successive transparent glaze will change and deepen the color right on the paper itself. This method gives you almost infinite control. If the glaze mixture is laden with pigment, the color and value will deepen quickly; if the glaze is very thin and watery with little pigment content, the buildup progresses slowly, but with infinite possible variations in color and tone.

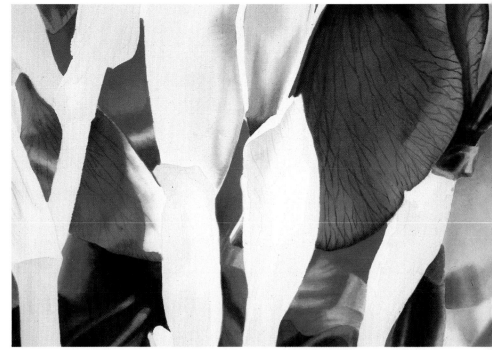

Step Three

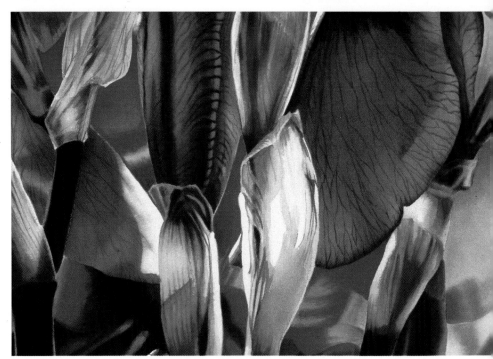

Step Four

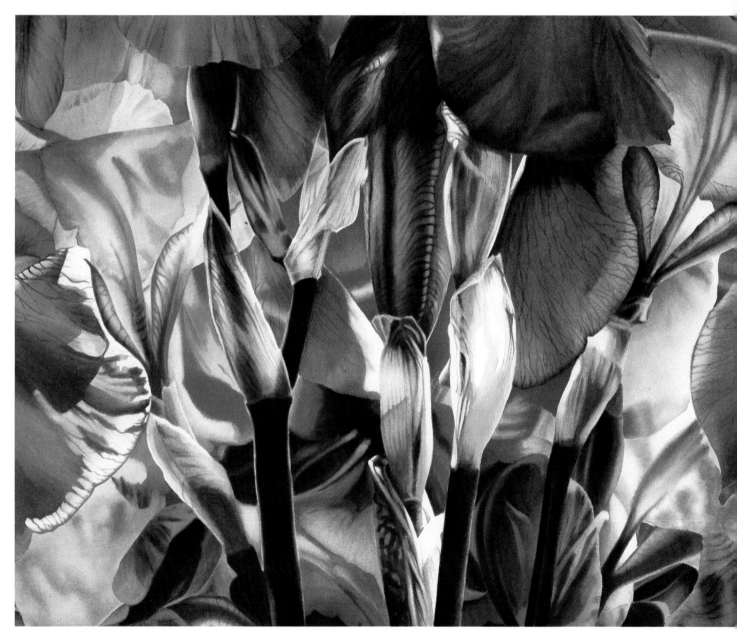

Red, Light and Blue, Barbara Buer,
22" × 30"

Step Five

Be aware of the need for the dark shapes that trail through the lower portion of the composition, holding up and tying the vertical lines together. These dark shapes are as important to the total look of the piece as capturing the sunlight and the flowers' transparency.

Painting a Velvety Surface
With Liquid Acrylics

Before she begins, Norma Auer Adams mixes enough paint to complete the painting. She buys acrylics in jars and then mixes and thins the colors with equal parts of gloss acrylic medium and water. She strains each color through a piece of silkscreen cloth into a pint jar, and then stores the paint in a refrigerator. The finished colors in her paintings result from many thin, airbrushed layers of these colors.

Step One

Adams begins by drawing the subject onto stretched and gessoed canvas. She masks off the large flower shape with frisket film, then sprays the background as shown here.

Step Two

She removes the frisket film, leaving a white shape in the center. She starts painting the actual flower with the focal point, the section in the middle. She masks off the rest of the flower and sprays each little segment of the stamen in sequence.

Step One

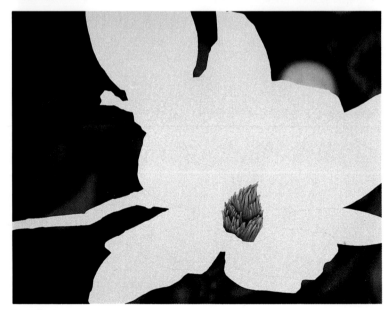

Step Two

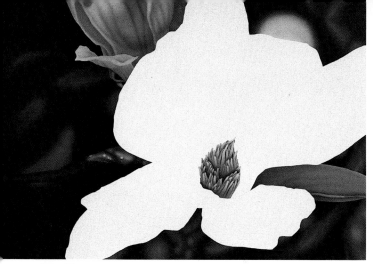

Step Three

Step Three

The next sections to paint are the pink areas behind the large white flower. Even though they are on opposite sides of the flower, she paints them at the same time because they are the same color.

Details *In the details you can see the smooth surface and crisp edges Adams achieves with her airbrush technique. Notice the subtle color changes of stems and leaves behind the flower.*

Finally Adams paints the large white flower. She uses the same system of masking and spraying to build up the shadow of areas. She also masks off completed areas of the painting to protect them from later layers of paint.

Magnolias, Red and White, Norma Auer Adams, 36" × 48", Acrylic

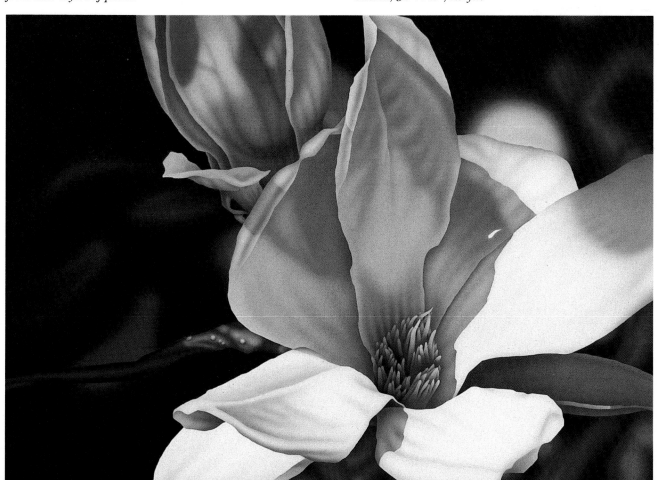

Catching a Subject's Luminosity

DEMONSTRATION

The painting *Ballet Roses* demonstrates a light that appears to originate from within the subject—illuminating the composition rather than being illuminated by an outside light source.

Step One

Begin by carefully arranging the roses in an interesting pattern. The table, leaves and background all must be subordinate to the glowing quality of the roses.

Step Two

Apply Permanent Rose and Red Rose Deep to the roses. To ensure soft edges on the flowers, cover the rest of the page with Phthalo Green while they are still wet. Add a glaze of Red Rose Deep to neutralize the green. Paint the table and the portion of the table seen through the vase with a neutral mixture of New Gamboge, Permanent Rose and Cobalt Blue. The initial covering of the paper should be done very quickly, but now you can work more slowly and deliberately.

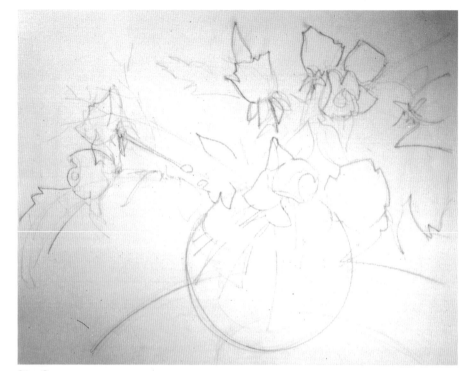

Step One

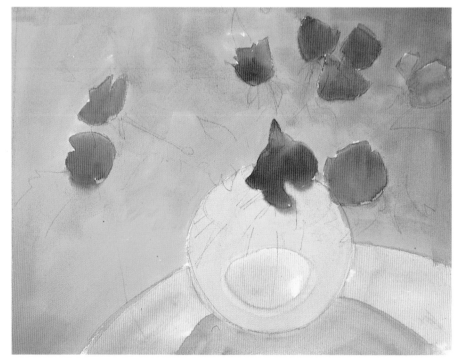

Step Two

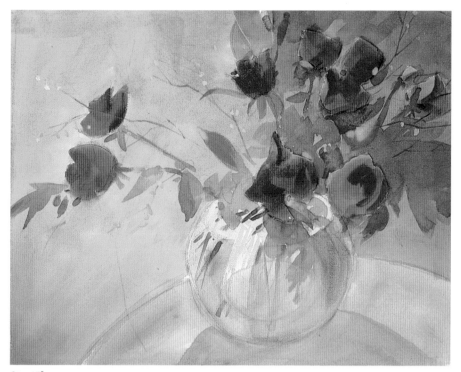

Step Three

Step Three

Every application of color is related to the pure color of the roses to capture their luminosity. The value of the leaves is slightly darker and more neutral than the background. The base color in the leaves is Viridian Green. Cobalt Blue and Permanent Rose define the patterns on the vase. Pure Red Rose Deep gives minimal form to the roses. Too much detail would diminish the desired color effect.

Step Four

Darken the table to reduce its importance, and add details. The artist, Skip Lawrence, and his wife gave these roses to their daughter after her performance in the Nutcracker. Without emotional involvement, painting is a hollow exercise in moving your hand.

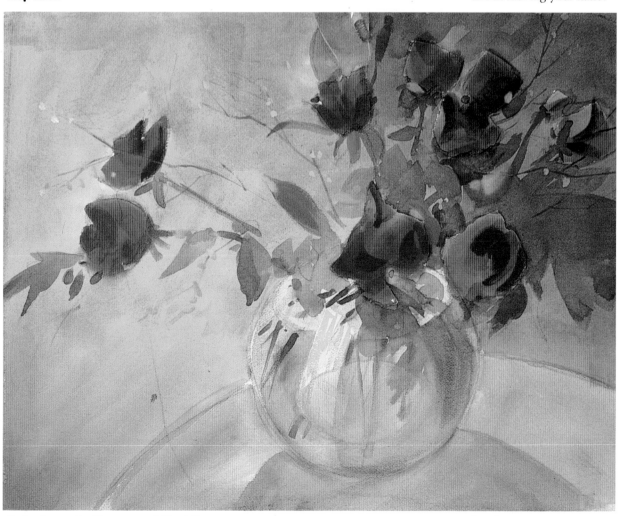

Ballet Roses, Skip Lawrence, 20" × 26"

Step Four

Painting Complementary Values

DEMONSTRATION

Step One

A single Sandra Kaplan watercolor of florals or floral landscape subjects can cover an entire wall. Painting on such a large scale, Kaplan needs some way to control the composition. She uses monochromatic underpainting as the initial value structure that holds the image together. The underpainting is done in a color that is a complement to the dominant color planned for the piece. After the values are set, she builds up the color with transparent washes.

By defining the values at the beginning, Kaplan is able to work more freely with subsequent colors—the design of the piece is already set. Using complementary colors first gives later colors a greater richness.

Kaplan says about her paintings, "The actual, physical subject is not my primary concern. I like that the lights and darks break up those forms, creating new abstract forms."

Step One

Working from a slide or from life, Kaplan does a very detailed drawing of the subject in colored pencil. Begin the painting by laying down the value relationships. Most of the painting is in green, so use a complementary warm violet for the underpainting.

Step Two

Next, paint the lightest flowers so the rest of the painting can be done in relation to those colors.

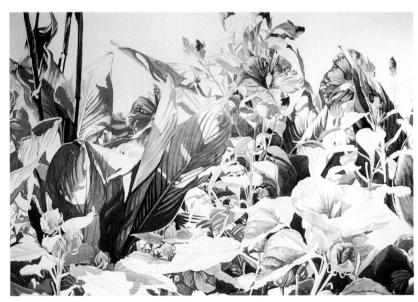

Step Two

Step Three

Add a green wash to the areas adjacent to the flowers. The values are already set, so the primary concern here is with color relationships. Glaze warm and cool greens to establish highlights and shadows.

Step Four

With the final glazes applied, the understructure of value is no longer separate, but an integral part of the color values.

Step Three

Hibiscus With Canna Leaves, Sandra Kaplan, Watercolor, 40″ × 60″

Step Four

Produce Moods With Dramatic Contrast

DEMONSTRATION

Two ways of using strong value contrast are illustrated in these paintings by Barbara Buer. She is fascinated with both strong backlighting, which produces a dark subject against a bright background, and the equally dramatic spotlight effect, where the subject is bathed in bright light against a very dark background. The lighting in *Dogwood and Cup* produces a mysterious effect, while the bright sunlight in *Red Roses* communicates a happy, warm feeling. "The use of tonal values in *Dogwood* is what makes the painting," Buer says. "The extremely dark background is what makes the flowers and cup so brilliant."

To get the dark background in Dogwood and Cup, *Buer (1) painted her subject first with acrylic paint thinned to the consistency of watercolor, (2) applied masking fluid over the acrylic, a process that would have pulled off watercolor, and (3) applied numerous watercolor glazes to the background.*

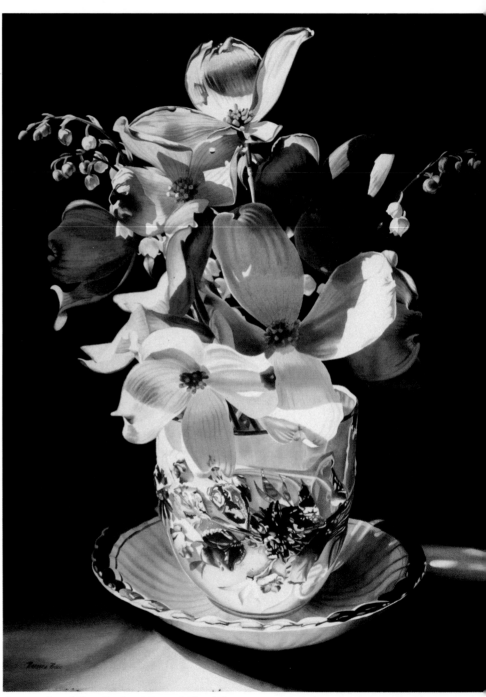

Dogwood and Cup, Barbara Buer, 36″ × 48″

Basic Flower Painting Techniques in Watercolor

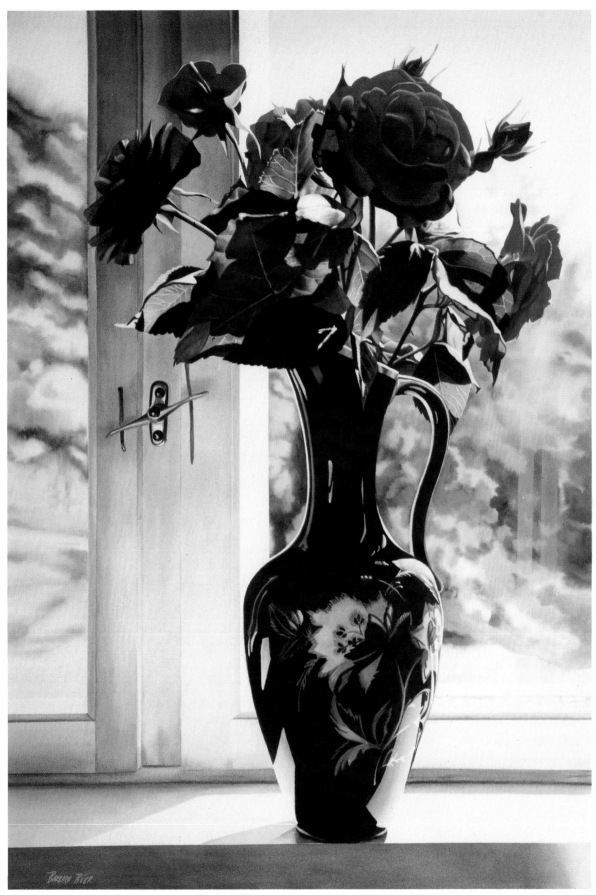

Red Roses, Blue Vase, Barbara Buer, 36" × 48"

Designing Florals With Black

DEMONSTRATION

Kendahl Jan Jubb specializes in images built of numerous textured shapes. She works on balancing the textures so the composition will hang together and not break apart into individual patterns. Values are crucial.

In developing a composition, Jubb starts with the focal point. She puts in the pivotal shape and then develops the patterns that lead away from or to that form, using the arrangement of textures to provide movement.

Jubb is not afraid of black. Although she does treat the powerful, dark value with respect, she relies on it heavily to provide a weighty contrast to her intricate patterns. She sees the negative space as an integral part of her compositions, and by using black she is able to give the negative space more importance.

Jubb sees value as drama and uses a lot of contrast. She uses black because of its dramatic value; black makes the other colors more brilliant and gives the negative space more depth and more weight.

Step One

Jubb begins with a careful drawing of all of the shapes that will go into the painting, even including the tiny shapes that will form the pattern in the flowers. She starts painting by completing all of the pink petals.

Step Two

Working color by color, she adds all of the blue, most of the yellow and green, and some of the red.

Step One

Step Two

Basic Flower Painting Techniques in Watercolor

Step Three

Now, with all of the colors placed in the subject, she begins to add black to the negative space. The flowers have a light, airy feel with white around them; this will change as the negative space is filled in.

Step Four

Colors intensify and the flowers look dramatic as they are surrounded by black. Compare Step Three to this final image, you can see how powerful the composition is with black rather than white. The repeated shapes of the peach and the group of peaches is interesting. Repeating shapes or patterns, in a design with many shapes or textures, adds harmony to the total structure.

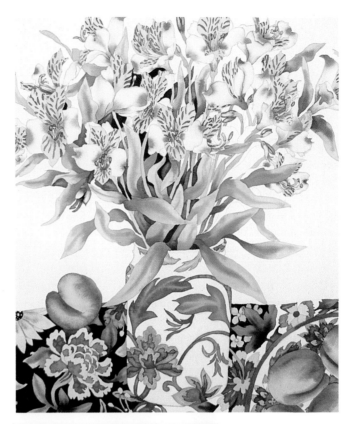

Step Three

NEGATIVE SPACE EXERCISE

Arrange three or four objects into a single still life. Draw the outlines of each of the objects and fill all the space outside the objects with black. Do not draw anything inside the objects.

When the negative space and the objects are divided into black and white, you can clearly see how the objects fit into the format. Are the objects balanced? If not, do they need to be moved, or could another object be added somewhere else in the composition to balance them?

Step Four

July Arrangement With Peaches, Kendahl Jan Jubb, 25" × 22", Watercolor

Layer Color to Make Opaque Areas

atercolor is most often talked about as a transparent medium. And it is. But that transparency is relative. There are degrees of transparency, depending on the pigments you actually use; some are more or less transparent than others. Artist Arne Nyback prefers to control transparency in his floral paintings, often building strong opaque passages to give flowers a certain weight.

Layering and combining transparent and opaque paints creates exciting color depth. The more layers of color you apply, the more opaque your result will be. Which colors you layer is important, too. For example, yellow layered over purple (when dry) will mix optically to form gray. When an earth tone or opaque color is used in one of the layers, the result will appear even more opaque. Keep each layer quite thin to create an opacity that increases gradually. The combination of layers is like very thin veils of different color placed in a stack; even through the top veil, you can see the effect of the bottom one.

The weight of the flowers makes them appear real. Nyback continued to layer more naturally opaque watercolors over transparent pigments, using heavier densities to build up that weight.

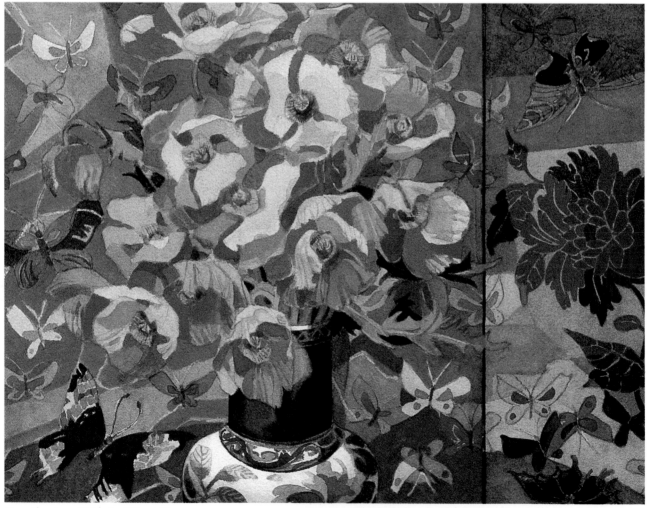

Poppies, Arne Nyback, 23" × 30"

Basic Flower Painting Techniques in Watercolor

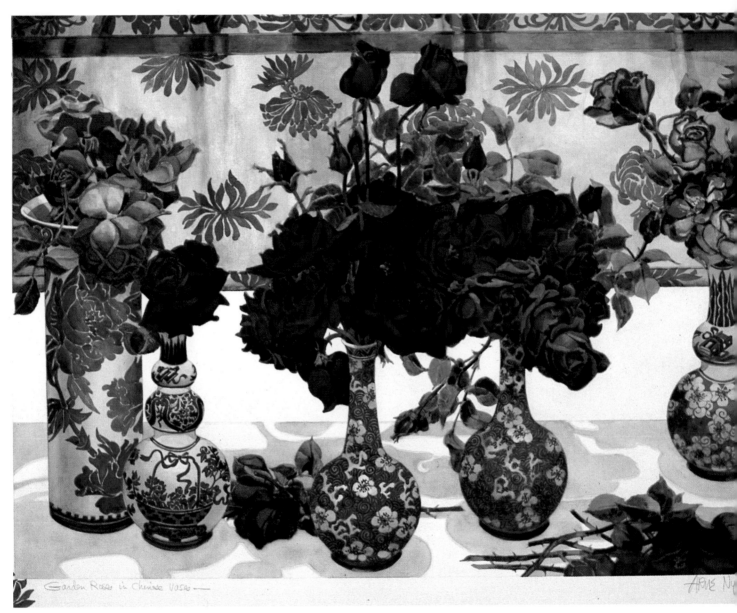

Garden Roses in Chinese Vases, Arne Nyback, 29" × 40"

The white in the vases in Garden Roses in Chinese Vases *is not the white of the paper, but rather the result of many layers of blue, Yellow Ochre and Chinese White. The color in the vases must be built up as much as the color in the flowers to give it the same weight, authority and believability as the rest of the painting.*

THREE WAYS TO BUILD OPACITY IN WATERCOLOR

1. Concentrate on using the more opaque watercolors, such as Yellow Ochre and Raw Sienna.
2. Control the mixing of your washes and layers and combine colors.
3. Thin your paint with enough water and the pigment particles will spread apart. The result will be less dense and more transparent. A very thin wash of even the most opaque color will allow the white paper or the color beneath to show through.

Layer Color to Make Opaque Areas

DEMONSTRATION

Step One

Nyback transferred his original drawing for *Tulips Posing in Secretness* to illustration board by rubbing the back of the drawing paper with graphite and then tracing the lines. The lines of the drawing have such vitality that you can let them show through in certain areas of the final painting. Once the lines are transferred, begin building the vase with a light wash of Cobalt Blue.

Step Two

Paint the porcelain vase with a light wash of Yellow Ochre, and shade it with a mixture of Yellow Ochre and Cobalt Blue. Over that, add patterns freehand. Then paint the stems with a wash of Cerulean Blue followed by lighter layers of Winsor Yellow, Sap Green and more Cerulean Blue. Nyback used the more opaque colors, since the stems needed a heavy look.

Step Three

Build up the light-valued tulips with approximately fifteen layers of paint so that their opacity will match the weight of the rest of the painting. To build opacity that won't look flat, layer Ultramarine Blue first, and then layer Chinese White over Yellow Ochre.

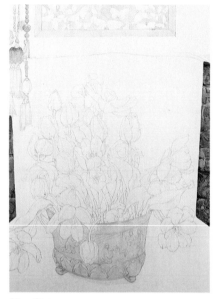

Step One

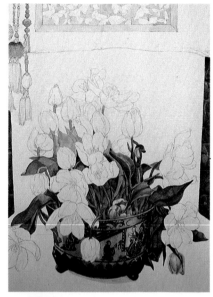

Step Two

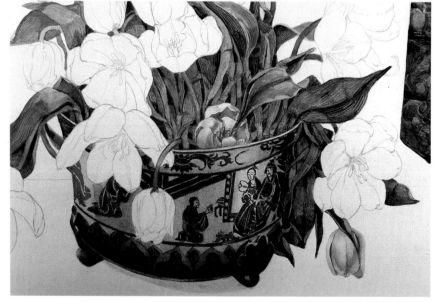

Step Three

Basic Flower Painting Techniques in Watercolor

Step Four

Step Four

The top area shows the tulips in the initial stage of development; below them, the tulips are closer to their finished state. At the top, you can see how transparent the first wash of Alizarin Crimson is, with pencil lines still showing through. Continue to build opacity and weight by adding a thin wash of Yellow Ochre. Then intensify the color with Cadmium Orange applied thickly so that the brushstrokes help shape the petals. Use Cobalt Blue for the shadows. Since blue complements the orange and crimson, they work together to form a slightly gray tone.

Step Five

Although it was painted last, the background provided the important foil to the flower heads. Nyback decided on a mixture of cobalt Blue, Cadmium Yellow and Chinese White for the background because these colors blend with others in the composition.

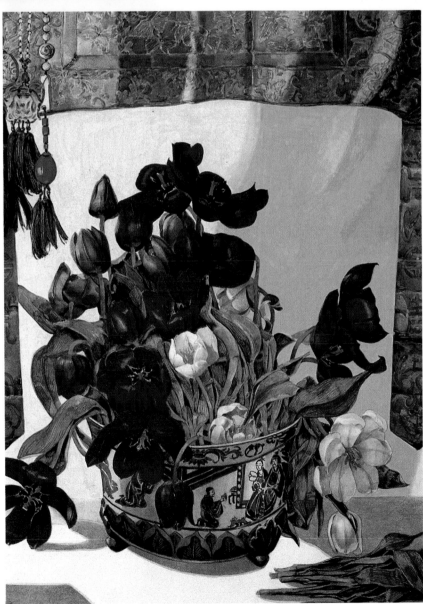

Step Five

Tulips In Secretness, Arne Nyback, 30″ × 20″

Painting Flowers With Water

E dith Bergstrom begins a work by planning the painting—using her hundreds of outdoor photographs as a source.

Palm Patterns #85, Edith Bergstrom, 22″ × 30″

Numerous layers of watercolor on damp paper give Palm Patterns #85 *a soft, even look that represents the gentle filtering of light through the branches. Building layers also allows for subtle modulations of color and value, as in the accordionlike shapes of the palm leaves in the left area. Damp paper keeps the edges of washes from becoming sharp.*

Photos and research by Sara Richardson.

Basic Flower Painting Techniques in Watercolor

Using Wet Paper

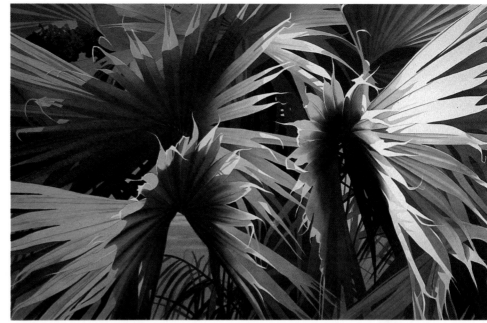

Applying a base wash of yellow.

After a sketch is done, Bergstrom completely drenches both sides of the paper with water and applies one or more of several yellows, depending on the effect she wants to capture. She deposits more pigment in areas that will later be dark. It is important to wait until the paper has dried thoroughly before applying a second coat of color. By the next day the pigment is thoroughly set; it won't run or lift off the paper easily.

Palm Patterns #125, Edith Bergstrom, 34½" × 51¼"

In Palm Patterns #125, *Bergstrom began by applying washes of various yellows. After this stage had set up, she remoistened the paper and she established the cool tones with layers of Cobalt Blue. This process formed the beginning of the warm/cool color scheme seen in the finished work.*

Using Cobalt Blue for the second wash.

Carefully rewet both sides of the paper and let it drain; it should be damp, but dry enough that paint won't spread by itself when it touches the surface. Brush on the second coat of paint, which is usually Cobalt Blue. These two initial washes begin to establish the cool/warm, light/dark contrasts and succeeding color harmonies.

Keeping edges soft.

Continue to rewet both sides of the paper daily before colors are added. The pigment distributes itself more evenly on a slightly damp paper. Keeping the edges of shapes relatively soft, which is particularly important for dark, velvety shadows. Each day, when through working, allow the paper to dry out thoroughly, resetting the glazes. Do not use pigments like Winsor Green or Winsor Violet—these colors will not set up and redissolve when the paper is moistened.

Layering thin washes.

Add successive colors in thin washes, which overlap in new patterns with application. Don't apply equally thin in all areas. Darker shapes often receive more pigment; successive layers may deposit heavier pigment in those areas or in others, depending on the color harmonies you build.

Here you can see how a fairly wet wash by itself can create textures on the damp paper. The thin washes of color separate and settle evenly into the tooth and texture of the paper.

Painting Flowers With Water

Paint With Water First

Artist Joan McKasson strives to make her work emotionally charged. Her painting technique is geared toward giving plenty of color excitement and variety through the ways watercolor washes run and blend together. But if her paintings had only this quality, they might end up as chaotic messes. Her trick is to let watercolor do its flowing thing, but to keep it under control.

Paint with washes of clear water.

To create compositions that are controlled but at the same time loose, McKasson prefers not to draw on the paper first. She begins by painting with washes of clear water on a dry sheet of paper. Paint in shapes with a 1½- or 2-inch brush and plenty of water, and spontaneously brush in patterns. Many of the areas will run together, creating new or unexpected shapes and patterns, and what you're left with is a wet and dry surface to begin painting on.

Add watercolor paint.

Add partially mixed watercolor paint (the color not fully blended on the brush), correcting the value and color as you work. The paint can now mix and flow freely in the wet areas, yet retain crispness where it meets the dry paper. If the paper gets too wet, simply sponge off the excess moisture with paper towels. This way, you are able to establish the composition, form and vibrancy of the painting, making the most use of watercolor's ability to run and flow.

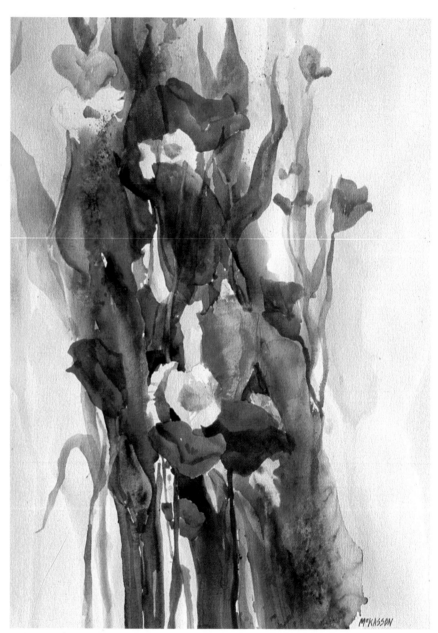

In Sea Garden, *Joan McKasson emphasizes the strong vertical thrust of the flower stalks. Within the powerful dark shape is an interplay of strong value contrasts—lights and darks—and within those darks, you'll find beautiful watercolor blendings. She makes use of watercolor's natural capability to flow freely within a defined composition.*

Sea Garden, Joan McKasson, 29" × 21"

Basic Flower Painting Techniques in Watercolor

Draw with watercolor pencils.

Once this stage of the painting is set and the pigments begin to settle, McKasson often draws directly into the painted areas with Caran d'Ache watercolor pencils to develop the subject matter. Occasionally, McKasson dries the paper surface with a small hair dryer and draws the images with a lead pencil.

View in reverse.

To finish, evaluate the painting by looking at it in a mirror about 50 feet from the easel. By viewing the painting in reverse, you see it with a fresh eye.

Here's what drawing with water looks like on your paper. The watercolor flows freely within the wet area, yet is encompassed by the surrounding dry area. This makes it possible to get a loose effect under very controlled conditions.

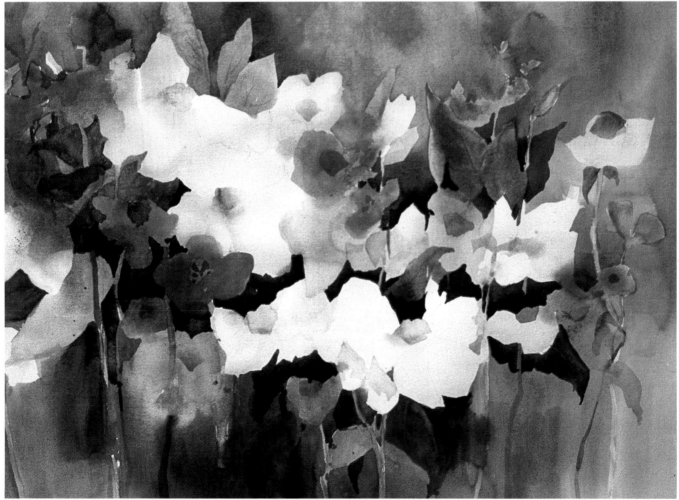

After the Spring Rain, Joan McKasson, 20" × 28"

Clean, Crisp Edges *McKasson started this piece by painting the negative space around the positive flower shapes with clear water. When pigment was added, the wash bloomed and spread until it met dry paper, giving the flowers clean, crisp edges. Thus, even the edges of dark, dense shapes can remain clear. Balanced with the softer wet-into-wet blendings, this creates a dynamic contrast.*

Accent Your Watercolor Florals With Penmanship

Flowers painted with washes of watercolor seem all the more fragile when contrasted with the bold look of pen and ink.

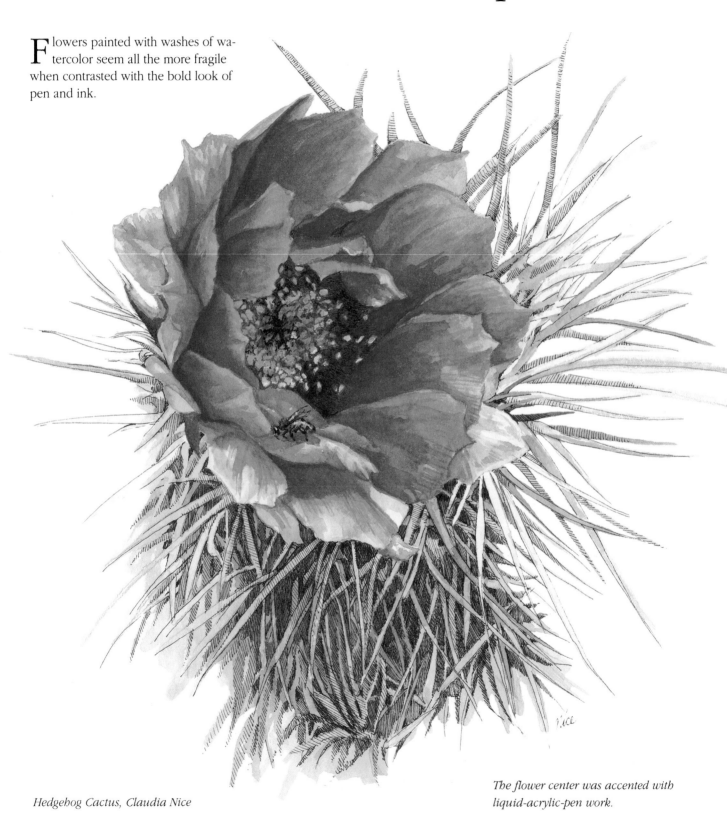

Hedgehog Cactus, Claudia Nice

The flower center was accented with liquid-acrylic-pen work.

Basic Flower Painting Techniques in Watercolor

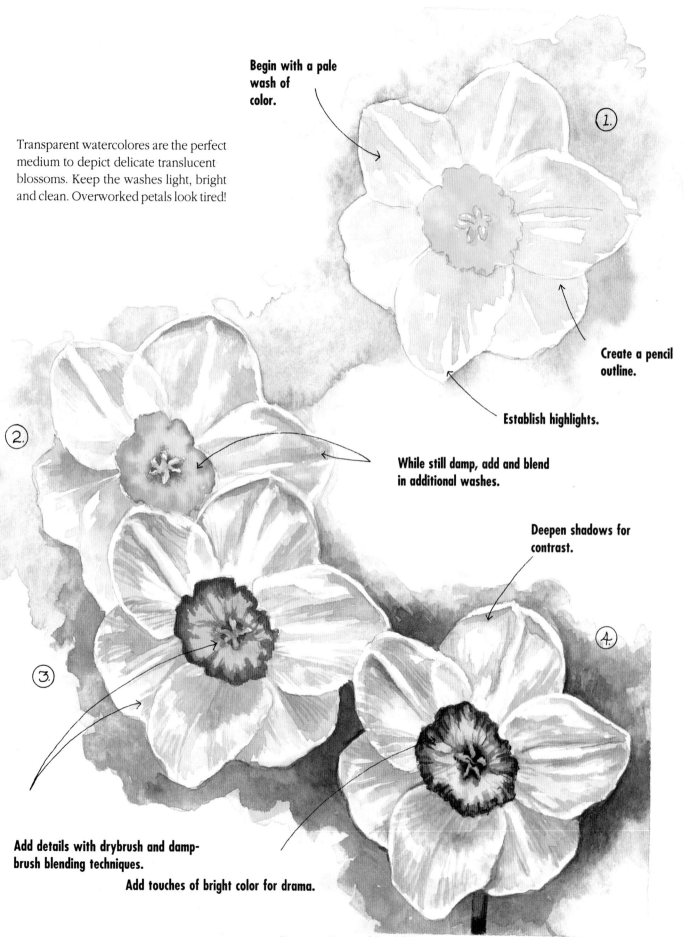

Begin with a pale
wash of
color.

1.

Transparent watercolores are the perfect
medium to depict delicate translucent
blossoms. Keep the washes light, bright
and clean. Overworked petals look tired!

Create a pencil
outline.

Establish highlights.

2.

While still damp, add and blend
in additional washes.

Deepen shadows for
contrast.

4.

3.

Add details with drybrush and damp-
brush blending techniques.

Add touches of bright color for drama.

Varied Floral Textures

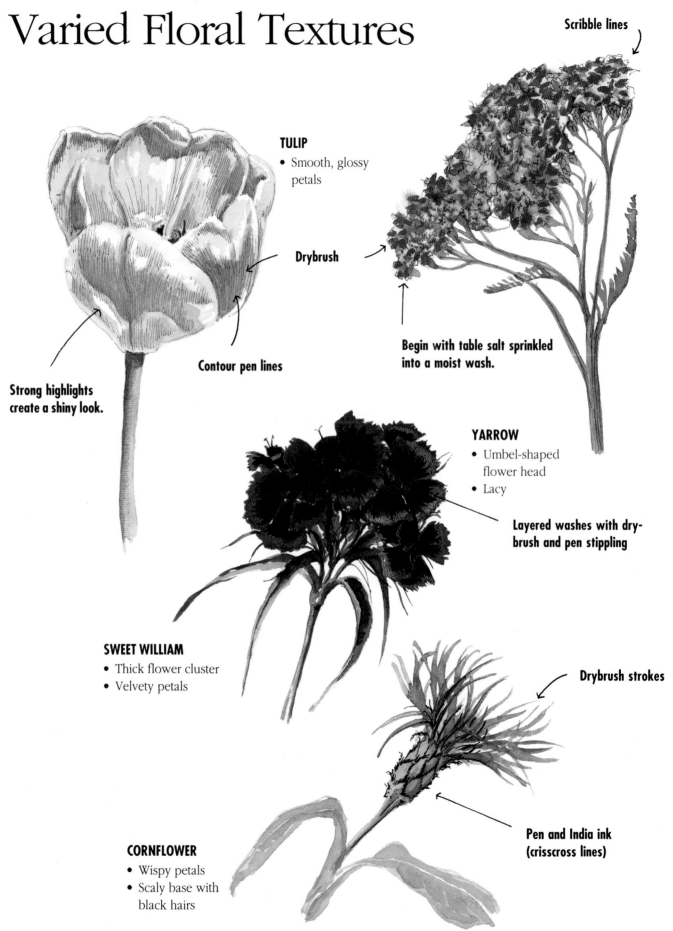

Scribble lines

TULIP
- Smooth, glossy petals

Drybrush

Contour pen lines

Strong highlights create a shiny look.

Begin with table salt sprinkled into a moist wash.

YARROW
- Umbel-shaped flower head
- Lacy

Layered washes with dry-brush and pen stippling

SWEET WILLIAM
- Thick flower cluster
- Velvety petals

Drybrush strokes

Pen and India ink (crisscross lines)

CORNFLOWER
- Wispy petals
- Scaly base with black hairs

Basic Flower Painting Techniques in Watercolor

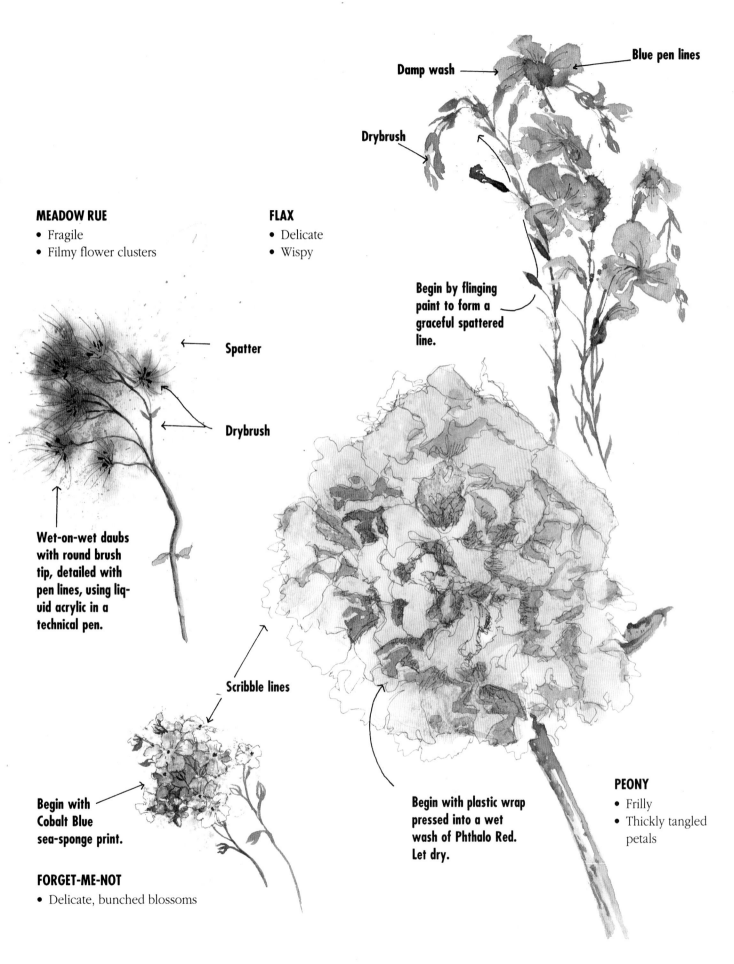

Damp wash

Blue pen lines

Drybrush

MEADOW RUE
- Fragile
- Filmy flower clusters

FLAX
- Delicate
- Wispy

Begin by flinging paint to form a graceful spattered line.

Spatter

Drybrush

Wet-on-wet daubs with round brush tip, detailed with pen lines, using liquid acrylic in a technical pen.

Scribble lines

Begin with Cobalt Blue sea-sponge print.

FORGET-ME-NOT
- Delicate, bunched blossoms

Begin with plastic wrap pressed into a wet wash of Phthalo Red. Let dry.

PEONY
- Frilly
- Thickly tangled petals

Varied Floral Textures

Leaf Textures

Leaves are as varied in size, shape and texture as the flowers they feed. A variety of pen strokes are useful in their portrait, as well as numerous watercolor techniques.

The following leaf examples are merely suggestions.

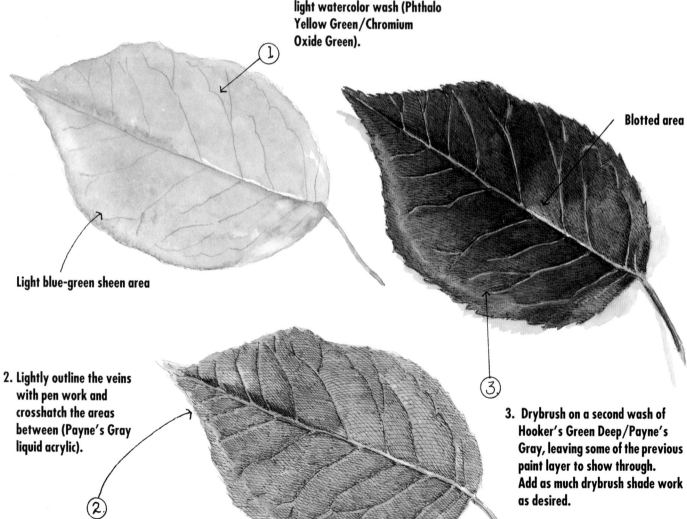

Pen and ink contour lines

MIXED MEDIA ROSE LEAF

1. Begin with a pencil sketch and a light watercolor wash (Phthalo Yellow Green/Chromium Oxide Green).

Light blue-green sheen area

Blotted area

2. Lightly outline the veins with pen work and crosshatch the areas between (Payne's Gray liquid acrylic).

3. Drybrush on a second wash of Hooker's Green Deep/Payne's Gray, leaving some of the previous paint layer to show through. Add as much drybrush shade work as desired.

Basic Flower Painting Techniques in Watercolor

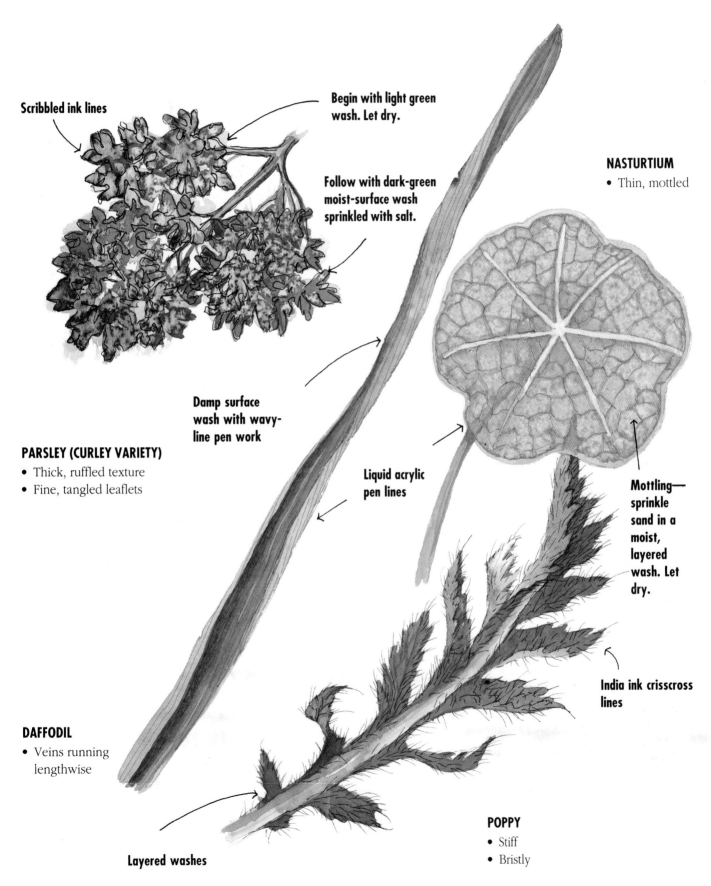

Scribbled ink lines

Begin with light green wash. Let dry.

Follow with dark-green moist-surface wash sprinkled with salt.

NASTURTIUM
- Thin, mottled

Damp surface wash with wavy-line pen work

PARSLEY (CURLEY VARIETY)
- Thick, ruffled texture
- Fine, tangled leaflets

Liquid acrylic pen lines

Mottling— sprinkle sand in a moist, layered wash. Let dry.

DAFFODIL
- Veins running lengthwise

India ink crisscross lines

Layered washes

POPPY
- Stiff
- Bristly

Weeds and Grasses

T he earthy colors and varied textures of grasses and weeds combine to make them exceptional subjects for close-up studies.

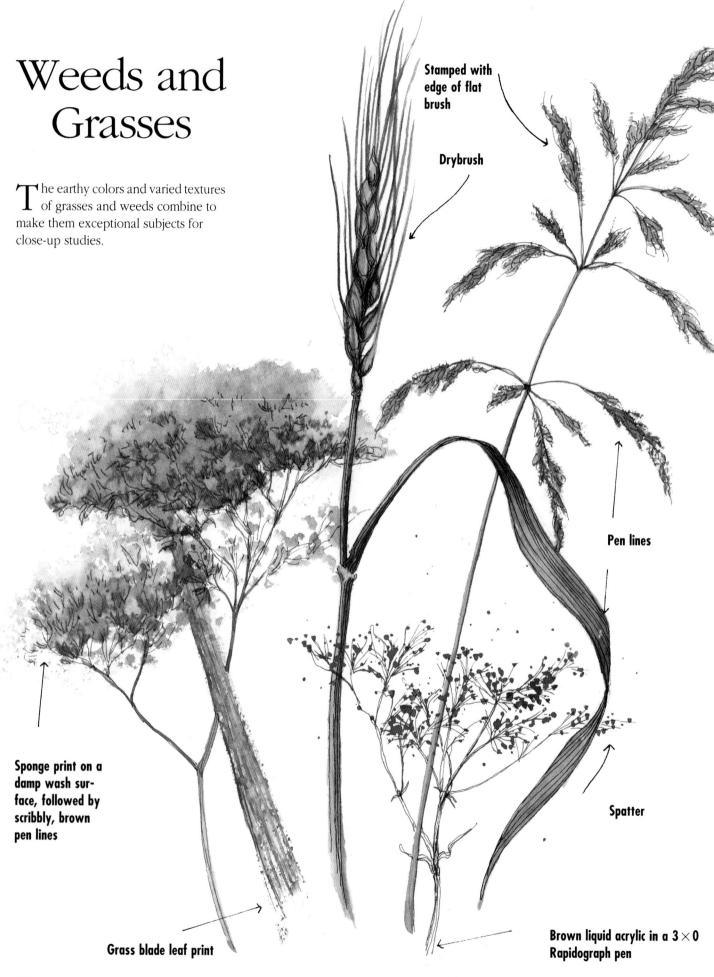

Stamped with edge of flat brush

Drybrush

Pen lines

Sponge print on a damp wash surface, followed by scribbly, brown pen lines

Spatter

Grass blade leaf print

Brown liquid acrylic in a 3 × 0 Rapidograph pen

Ink detail lines

Distant fields are depicted with simple washes, brushed while still damp with a few strokes of varied color (horizontal).

Add vertical drybrush strokes to suggest detailed grass areas.

Frayed flat brush

Liner brush

Fan brush

Light areas were masked during wash applications.

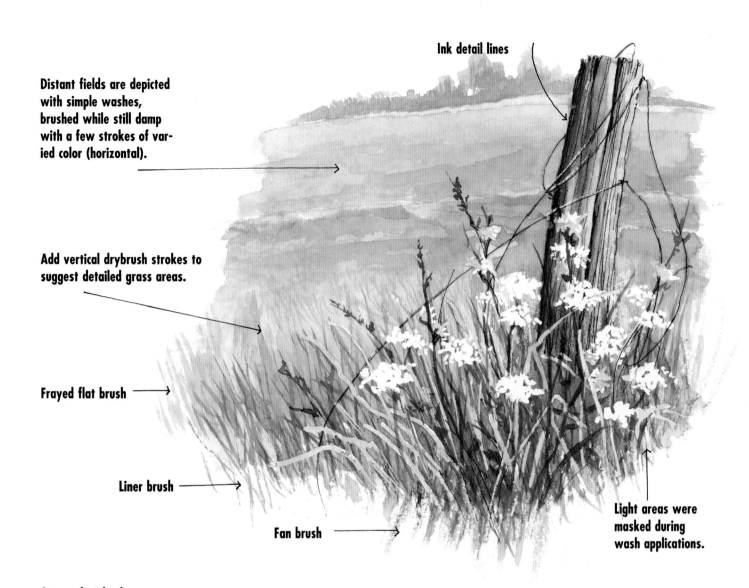

Stamped with edge of flat brush.

Sea-sponge drag marks

Criss-cross pen work.

Both spring and wintergrasses areas began as wet-on-wet washes.

Spatter

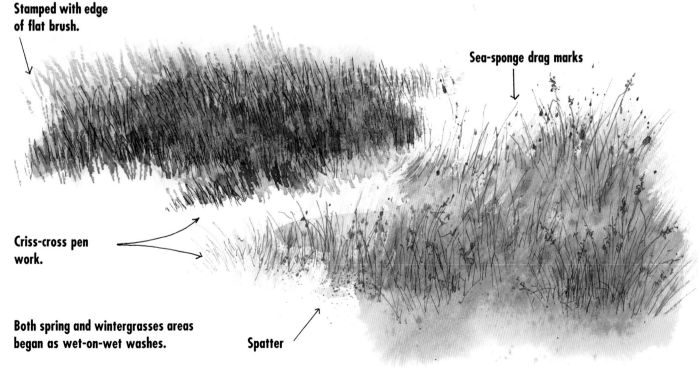

Painting Flowers From Photographs

Combine Photographs

Artists sometimes use a projector to superimpose one slide on top of another. The resulting image often provides the inspiration for a painting.

Combining the images from different photographs is an excellent way to use your photo collection to find exciting floral subjects. The painting on page 107 is a combination of elements in photos 1 and 2 (below). The direction of light is the same in both, so any part of either photo can be used to compose the painting.

After you've chosen parts of several photographs, the next step is to combine them into an interesting composition. A shortcut to exploring several floral arrangement possibilities is to place a piece of frosted acetate or tracing paper over the photo(s) and trace the flowers you want to use. When you have drawn several flowers on separate pieces of acetate, you are ready to rearrange them into a new composition simply by superimposing them and moving them around until you like what you see.

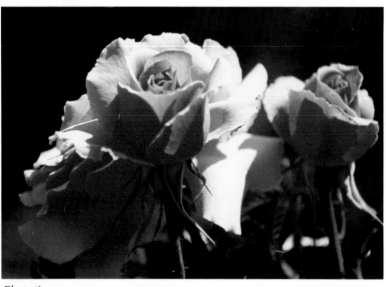

Photo 1

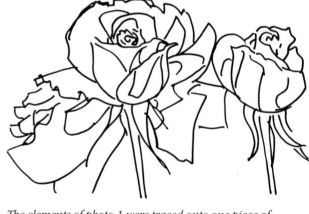

The elements of photo 1 were traced onto one piece of frosted acetate.

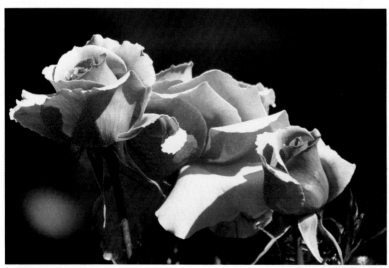

Photo 2

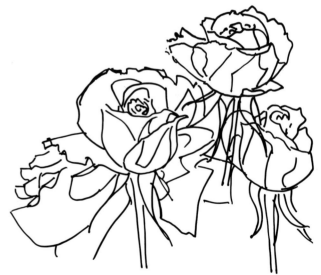

One rose from photo 2 was traced onto another piece of frosted acetate, then added to the tracing from photo 1.

Basic Flower Painting Techniques in Watercolor

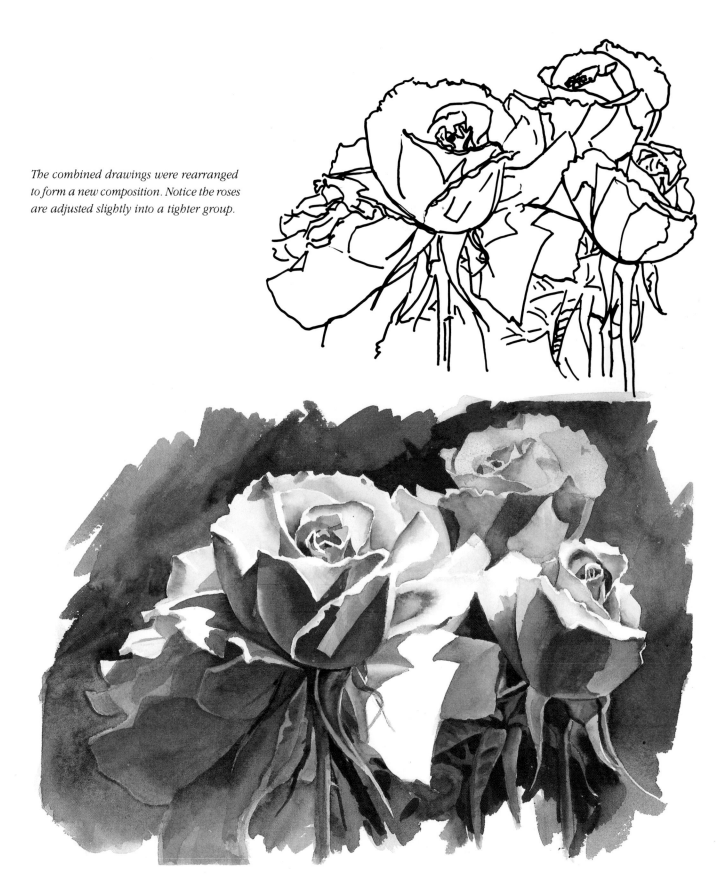

The combined drawings were rearranged to form a new composition. Notice the roses are adjusted slightly into a tighter group.

Finally, here's the watercolor sketch made from the new composition. The photos help keep the direction of the sunlight and shadows consistent.

Painting Flowers From Photographs

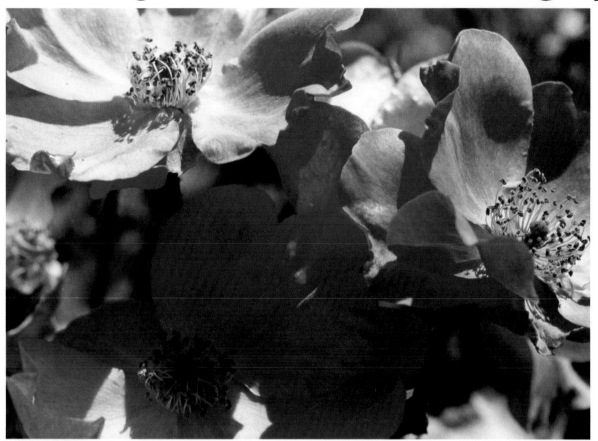

It is possible to find material for several paintings within a single photograph.

Several Paintings From One Photo

Often, you can find two or three beautiful floral designs within a single photograph. Make a couple of small mat corners from a piece of stiff paper and do some exploring in your photographs. In this photo, the artist found three designs almost immediately. This is a lot of fun, and you may even be inspired to paint your first abstract!

Use small mat corners to discover painting subjects within even the most unpromising photograph.

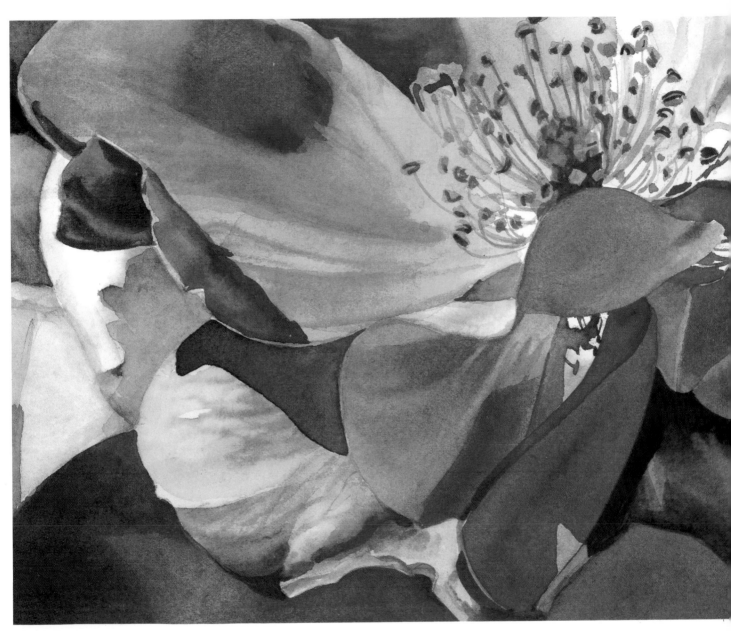

Floral Abstract, Jan Kunz
This is an abstract painting from a cropped portion
of the photograph.

Tip: Painting Dewdrops

Dewdrops and fun and easy to paint. They can add sparkle, but use them sparingly. Note that dewdrops always take on the hue of the object they are sitting on.

Step One

Draw the dewdrop in position. Wet the spot carefully, almost to the point of creating a puddle.

Step Two

Use a fairly dry brush to place a darker-value drop of the petal (or leaf) color into the part of the dewdrop that will face the light. Tip the paper, if necessary, to keep the color darkest near that end. Let it dry.

Step Three

Paint in the cast shadow color at the other end of the drop shape.

Step Four

Use a frisket or knife to lift a rounded highlight at the drop's sunlit end.

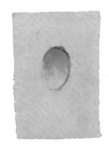

Petal Color

Leaf Color

Step One

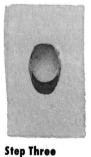
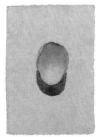

Step Two

Step Three

Step Four

Be careful that the dewdrops you paint have their shadow and sunny sides aligned in accordance with the rest of the painting.

Tip: Puddle and Pull

Y ou may find this puddle-and-pull
brushstroke useful when painting
pointed leaves and petals.

Step One

Use a fully loaded brush to apply color
to the tip of the petal you intend to paint.
The pigment should form a small pud-
dle.

Step Two

Wash out your brush in clear water.
Once clean, touch your brush to the
paint rag, but allow a moderate amount
of water to remain.

 Begin the stroke at the bottom of the
wet arrow shape, and pull the color
down, leaving an ever-lighter track.

Step Three

Let dry before going on to the next petal.
Try this stroke when you paint pointed
petals.

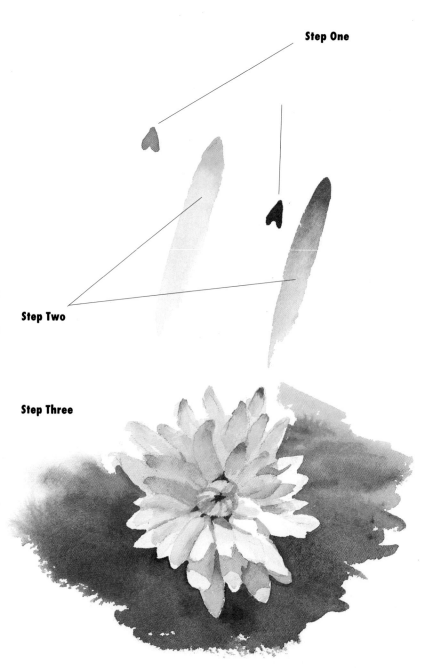

Step One

Step Two

Step Three

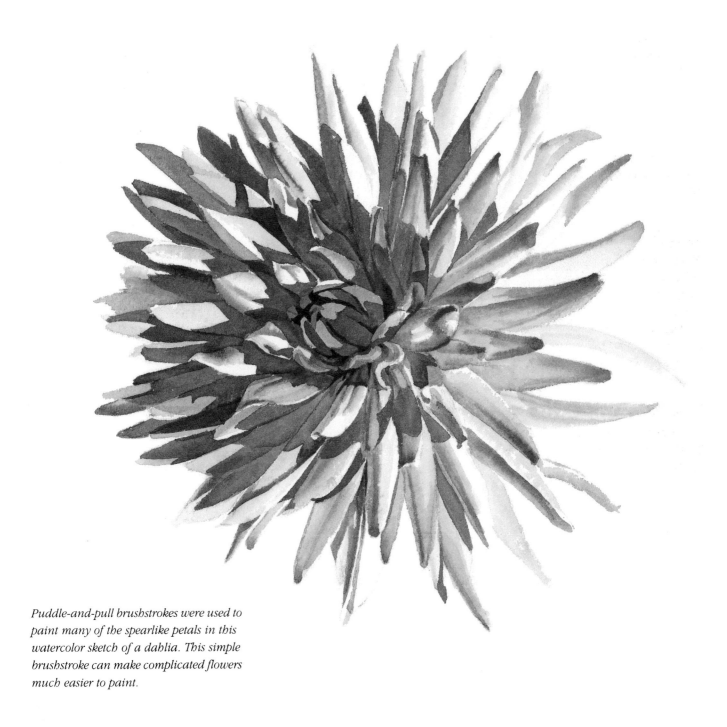

Puddle-and-pull brushstrokes were used to paint many of the spearlike petals in this watercolor sketch of a dahlia. This simple brushstroke can make complicated flowers much easier to paint.

Tip: Curled Edges

Many petals and leaves have curled edges, and depicting them presents a wonderful opportunity to add color and brilliance to your floral painting's shading. We can achieve the illusion of curled edges by remembering that surfaces become cooler in color temperatures as they turn from the light. Curled edges also receive reflected light from adjacent petals.

In this illustration, the petals of the rose curve in many directions, but the painting process is very much the same for all of them. Let's take a closer look at the petals in the boxed area. At right are three stages of development. Color and shadow shapes are exaggerated to help you see how they were painted.

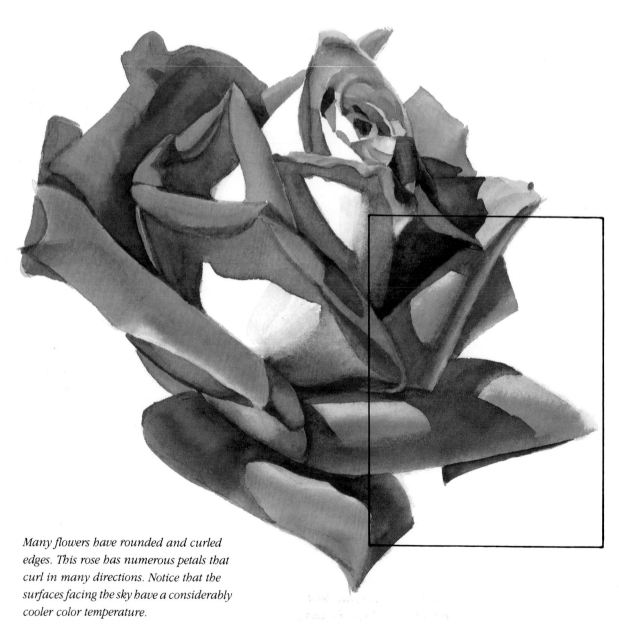

Many flowers have rounded and curled edges. This rose has numerous petals that curl in many directions. Notice that the surfaces facing the sky have a considerably cooler color temperature.

Basic Flower Painting Techniques in Watercolor

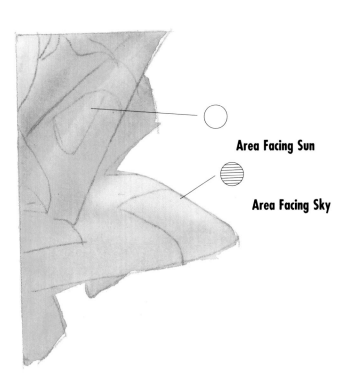

Area Facing Sun

Area Facing Sky

Reflected Light *If necessary, reinstate color on curved surface by first wetting the petal and then dashing in color along the length of the curve. Let it dry.*

Local Color *Paint local color, adjusting color temperature to reflect horizontal and vertical surfaces. Let it dry.*

Shadow Shapes
Have colors ready and know the boundaries of the shadow shapes before you begin! You will find it easier to work one petal at a time.

Complete one petal at a time. Add color along the entire shadow edge receiving reflected light. Keep it wet!

Add shadow color alongside the brilliant yellow passage and permit the colors to flow together. Complete the shadow. Let it dry before you begin the next petal.

Tip: Painting Around Complex Edges

A large background can be painted a portion at a time and still look as if it were completed in a single spectacular wash. Paint as far as you feel you have control of the medium, stop, let it dry, and then begin again. The trick is to keep the overlapping edges soft.

This technique is especially valuable when you paint around the complex shapes of blossoms. Plan ahead and have a place to stop before the paint begins to dry. Remember: Painting an area that has begun to dry causes runbacks.

Step One

Paint the flowers and stems first and let dry. Next, paint small areas between the stems and let dry.

Step Two

Before painting around the petals, prepare a place to stop by wetting (with clear water) an area at a comfortable distance.

Working on dry paper, point around the petals with the background colors. Stop at the wet boundary you have prepared and permit the colors to flow into it.

Step Three

Make ever-widening circles of color until the background is complete. Be sure to make the pre-wet area wet enough and wide enough (at least ¾") to prevent a hard edge.

Step Four

Add any details after the surface is dry.

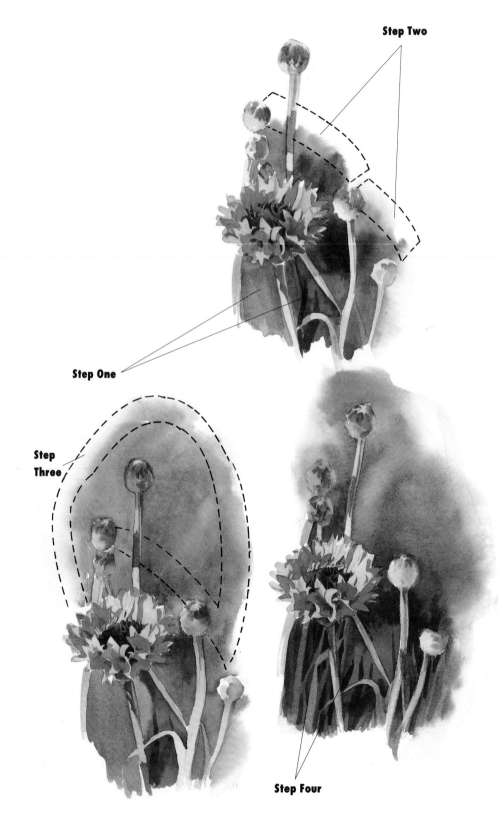

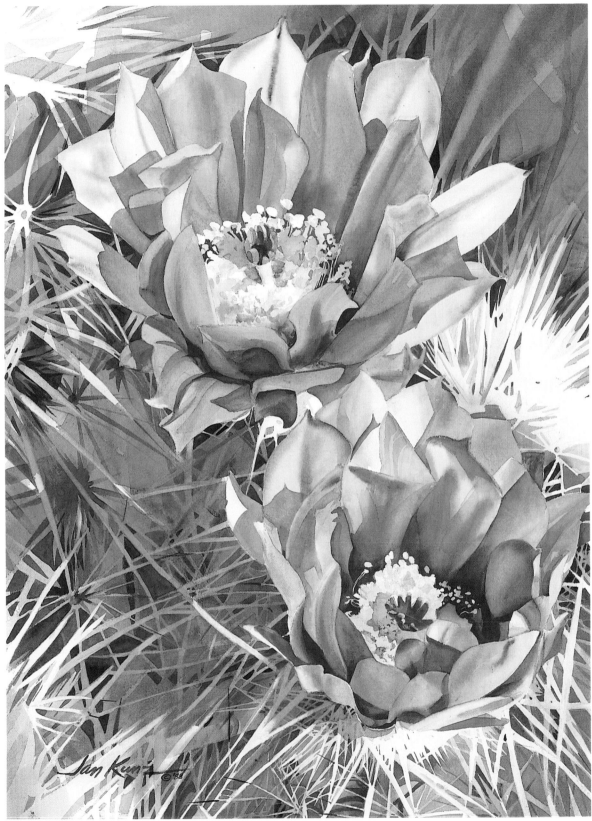

The cactus spikes provided natural stopping places for the background color, thus giving
Jan Kunz ample time to carefully paint around the cactus flower's petals. In some places,
she painted to a straight edge, leaving a white spike. Places where background colors
overlapped were concealed with the addition of a darker spike.

Cactus Flower, Jan Kunz,
30" × 19"

Tip: Cast Shadows

Cast shadows, like reflected light, offer an opportunity for color and interest. Since our eyes are accustomed to making the comparison between the edge of the shadow and the sunstruck surface, we think of shadows as cold and dark. We can add interest to shadow shapes if we take advantage of this phenomenon by painting the shadow's edges a cooler hue, but filling the rest of the cast shadow with lots of color. Use colors in the same value range, and usually from the same side of the color wheel. However, a warm touch in a cool shadow also works well.

**Ultramarine Blue + Raw Sienna
(Grayed Yellow)
Sap Green + New Gamboge**

Notice how the shadows appear colder where they meet the sunlit area. Often, cast shadows begin with a hard edge and become less distinct as the shadow lengthens.

In this painting of a rose, accurate placement of the shadow required great care. To represent sunlight, the cast shadow must be the same hue and 40 percent-plus darker than the object upon which it is cast. In this sketch (as in the one above left), the leading edge of the shadow is slightly cooler in color temperature than the body of the shadow shape.

Light penetrating glass can create interesting patterns within the shadow shape. You don't want these intriguing designs to overwhelm your composition, but they can be fun to paint. Start by painting the complete shadow shape. Once the paper has dried so the shine is no longer visible, lift the lighter shapes with a thirsty brush.

Tip: Cluster Blooms

Several varieties of flowers, such as hydrangeas and lilacs, consist of clusters of hundreds of individual blossoms. Even if it were possible to render each little blossom, the overall effect might be considerably less than desirable.

As a solution, determine the shape of the overall cluster and paint it first. After the basic form is complete, suggest individual blooms, making sure that the shape of the original cluster is perserved.

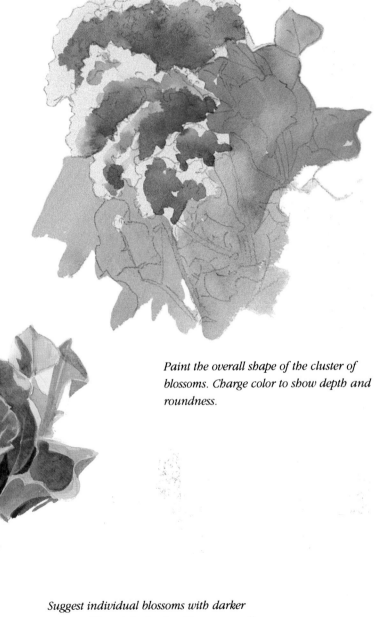

Paint the overall shape of the cluster of blossoms. Charge color to show depth and roundness.

Suggest individual blossoms with darker values of the original color. Choose a small area to complete in some detail, and leave the rest unfinished.

More Flower Painting Ideas

Find Flower Subjects on the Street

There are many ways to select subject matter for a watercolor flower painting. An idea may be triggered by something as simple as an interesting pattern of light hitting a garden, creating interest-ing shapes. Next time you go to a museum, take note of the way Renaissance painters made dynamic use of light and shadow.

Many artists stimulate the creative process by working on a theme. You can go to a location with a diverse display of flowers to study it in depth or to choose one simple bloom and try to work it into a balanced composition. In the case of *Depanneur, N.D.G.*, the artist was look-ing for a subject for a floral-painting competition. Instead of setting up a clas-sic still life with flowers in a vase, he de-cided to use this corner-store display.

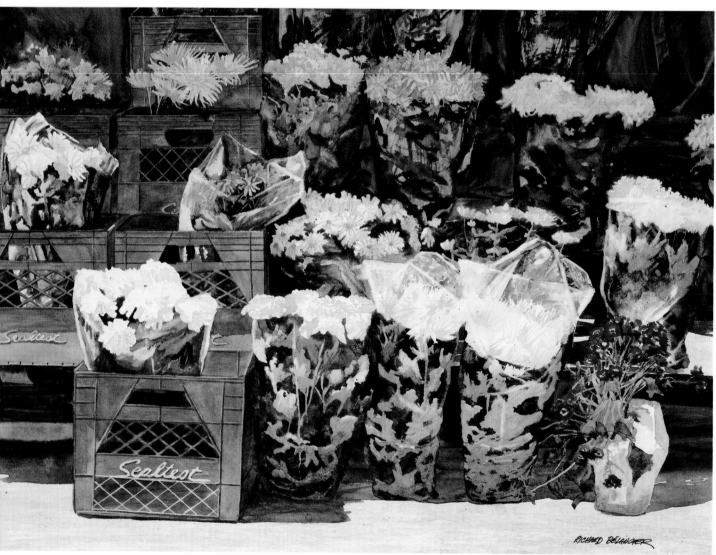

Depanneur N.D.G., Richard Belanger, 15" × 20"

Belanger started by masking the flowers with liquid frisket so he could render the back-ground by scrubbing paint around to create different textures. Several techniques were used here, including lifting, spattering and glazing. The first row of flowers was done in brilliant colors so they'd come forward.

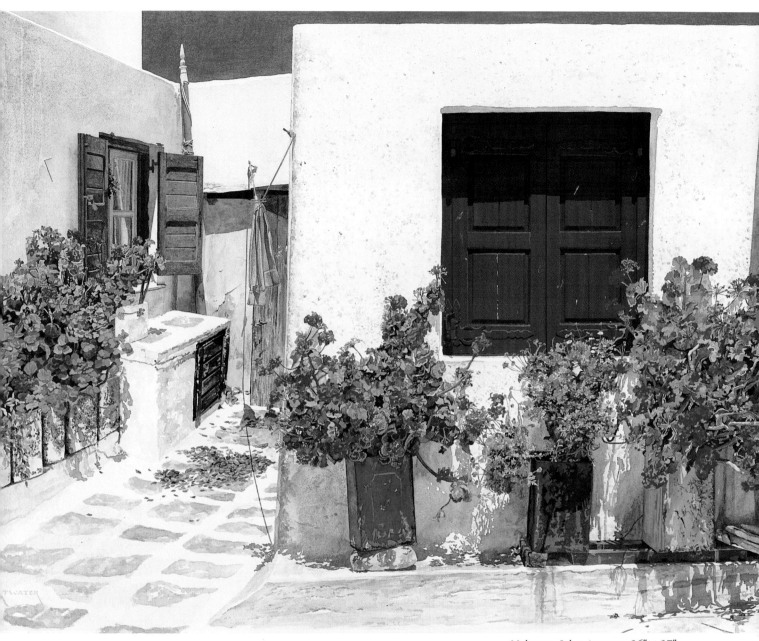

Mykonos, John Atwater, 26" × 37"

Juxtapose Bright White and Pure Color

A traditional painter's axiom says that intense light washes out intense color. But in *Mykonos* the primary impact of the painting is in the juxtaposition of bright white and pure deep colors, all saturated with light. The value range is quite broad, which, along with the colors, creates the striking contrast of the image. The hues in the plants, sky and window were accentuated by using the same hues in the shadow areas instead of grays. This further intensifies the feeling of warm, color-saturated light.

Attract the Viewer From a Distance

Nowhere in nature can you find purer color than sunlight passing through the petal of a flower. Larry Stephenson paints large, "in-your-face" paintings for maximum impact. He primarily works on 40″×60″ Arches watercolor paper. He wants his work to attract the viewer from a distance and to continue to entertain as the viewer moves closer to the painting.

Realism is very much a part of Stephenson's Oklahoma upbringing. He feels this part of the country still seems simpler and closer to the earth. He enjoys abstraction and owns a variety of types of art in his own collection, yet his paintings constantly reflect his conservative nature, sometimes with a twist. This can be seen in the borders of several of his recent pieces, such as *Rites of Spring*.

The floral center of Rites of Spring *was achieved by using transparent watercolor techniques. Stephenson applied layer after layer of controlled washes, gradually defining the hard edges. He used no masking agents. The borders were painted using opaque gouache.*

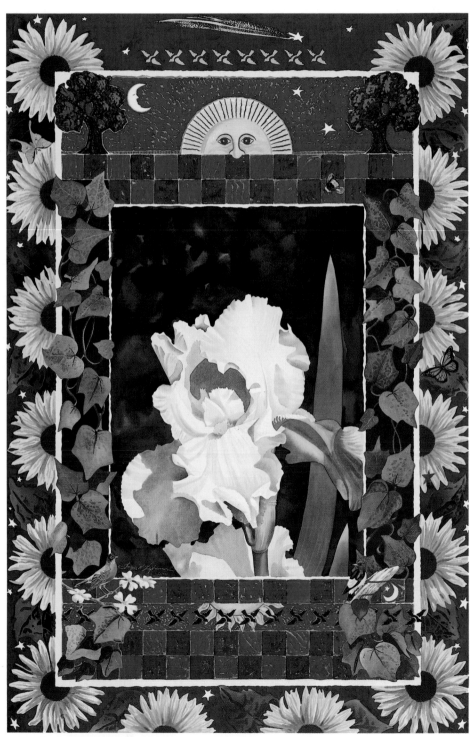

Rites of Spring, Larry K. Stephenson, 60″×40″

Basic Flower Painting Techniques in Watercolor

Let One Shape Dominate

The power of this watercolor by Jan Kunz is produced by contrasting the strong white shapes of the flowers with the background. Since all the flowers touch, they form one large, dominant shape. The artist makes this shape interesting by varying the dimensions of the negative shapes around it. Inside the white shape of the flowers delicate washes of warm and cool colors impart the glow of sunlight to the petals. The background is enlivened by pitting the cool, precise rendering of the leaves and stems against the warm, soft rendering of the soil below. Notice how Kunz paints negative shapes to suggest the more-distant background foliage; even though the background is full of interesting shapes, textures and contrasts, it still serves as a foil to the flowers. Kunz says her background in commercial art has helped her appreciate the importance of presenting only one message at a time in a composition. "The challenge now is to further simplify my paintings by learning to say more by saying less."

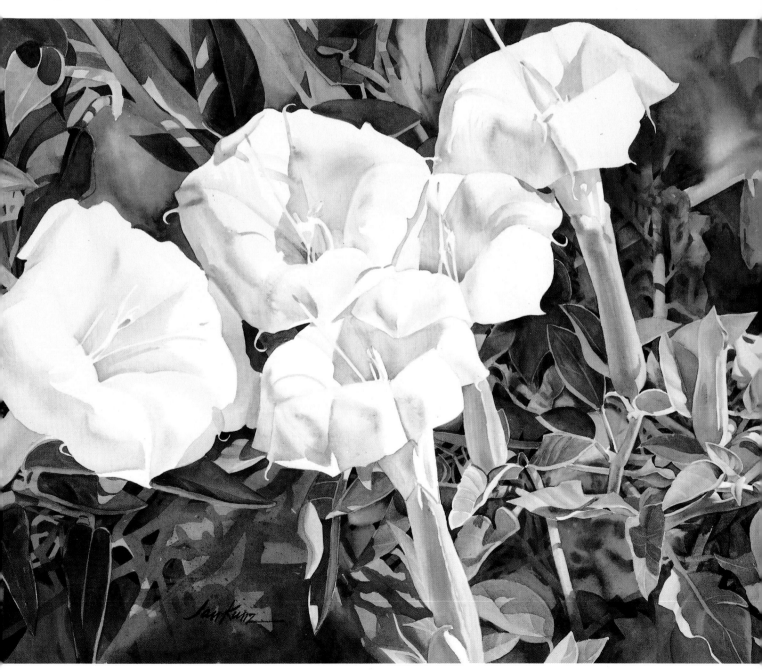

White Glory, Jan Kunz, 22" × 30"

Dutch Treat, Susan McKinnon Rasmussen, 21½" × 30¾"

Guide the Viewer's Eye With Color

No matter how many gray and rainy days there are in your area, you can capture the warm, sunny ones year-round in your paintings. In *Dutch Treat*, Susan McKinnon Rasmussen used bright colors, strong value contrast, and the white of the paper to capture a feeling of spar-

kling sunlight. The warm, bright colors of the tulips were placed against the cool darks of the background. The repeated colors of the flowers act like stepping-stones to bring the viewer's eye into and around the painting, giving us a "bee's-eye view" of the garden.

Pember simplified the subject with a careful drawing and used warm, intense colors. She tried to get the color down richly enough with the first wash to preserve its brilliance. Most areas were pre-wet before she floated color in, allowing it to mix on the paper. Shadow areas received some careful glazing to balance values.

Azalea, Ann Pember, 1½" × 29"

Appreciate the Abstract Patterns of Light

The expression of your feelings can give meaning to your work. Be selective in what you portray rather than copying exactly what you see.

Try using a close-up point of view and simplify shapes to create a stronger design and composition. By getting past seeing things as objects, you can appreciate their abstract qualities and see the relationships among shapes, rhythm, movement, composition, color, values and texture.

The abstract patterns created by light are fascinating and play an important role in Ann Pember's paintings. They help her to simplify design and strengthen composition. By simplifying the subject matter, you give viewers a chance to involve their own imagination and perhaps see things in a new way.

INDEX